*Harold Rosenberg* (signature)

PHILIP GUSTON

1975–1980

Private and Public Battles

# PHILIP GUSTON

## 1975–1980

## Private and Public Battles

by

KIM SICHEL AND MARY DRACH McINNES

BOSTON UNIVERSITY ART GALLERY

SEPTEMBER 17—OCTOBER 30, 1994

UNIVERSITY OF WASHINGTON PRESS

SEATTLE AND LONDON

BOSTON UNIVERSITY ART GALLERY

855 COMMONWEALTH AVENUE

BOSTON, MASSACHUSETTS 02215

© 1994 BY THE TRUSTEES OF BOSTON UNIVERSITY.

ALL RIGHTS RESERVED.

PRINTED IN THE UNITED STATES OF AMERICA.

LIBRARY OF CONGRESS CATALOGUE CARD NUMBER: 94-61046

ISBN: 1-881450-04-X

cover illustration: Philip Guston, *Aegean* (detail), 1978

Estate of Philip Guston, Courtesy McKee Gallery, New York

# CONTENTS

# ACKNOWLEDGMENTS

Guston's last paintings have become a metaphor for the often brutal collisions between the private world of the studio and the larger public world. The dialogue between these two spheres form the subject of this exhibition, *Philip Guston, 1975–1980: Private and Public Battles*. The paintings in this exhibition are a visual journal of the artist's concerns and conflicts in his last five years. The large-scale canvases, loaned from the estate of the artist, highlight both his private confrontations in the studio and his public meditations on war and aggression. During the 1970s, Guston addressed the current uneasiness and terror that marks contemporary daily life, and although he was often shunned for these paintings during his lifetime, they foreshadowed the concerns of many postmodern painters.

Guston influenced contemporary art through his teaching as well as his painting. He taught at Boston University, first as a University Professor from 1973 until 1978, and then as a Professor Emeritus from 1978 until his death in 1980. Before this tenure, Guston visited the university and participated in a public conversation with Professor Joseph Ablow in spring 1966. The transcript of this important dialogue, drawn from the Karl Fortess Collection in the Boston University Archives, is published here in full for the first time. The interview offers a revealing glimpse into the thinking that led Guston to the extraordinary paintings of his last decade.

This is the third exhibition of Guston's paintings at the Boston University Art Gallery. The gallery presented two monographic shows during the artist's early association with the university—first in 1970 and again in 1974. The present exhibition marks the twentieth anniversary of that 1974 show and includes ten major paintings made after that date during the extraordinarily prolific period when Guston was teaching at Boston University. We would like to thank the estate of Philip Guston and the McKee Gallery for the generosity of their loans. Throughout the preparation for the show, Musa and Thomas Mayer offered invaluable comments, hospitality, and thoughtful contributions to our project. Special thanks are also due to David McKee and his colleagues, Howard Watler and Bruce Hackney, of the McKee Gallery in New York for their participation in organizing this exhibition.

*Philip Guston, 1975–1980: Private and Public Battles* is one of three concurrent shows in the Boston area dealing with Guston's late work and his impact as a teacher. The Addison Gallery of American Art at Phillips Academy in Andover, a longterm collaborator of the Boston University Art Gallery, is presenting *Philip Guston's Poem-Pictures*, an exhibition of the artist's rarely shown drawings of the 1970s. The Addison show explores Guston's work with contemporary American writers. We gratefully acknowledge the cooperation and assistance of its director Jock Reynolds,

guest curator Debra Bricker Balken, and staff members Duncan Will and Alison Cleveland. The New Art Center in Newton is hosting *Legacy: Nine Artists Who Studied With Guston*, an exhibition of Boston University alumni. We acknowledge its curators, Roselyn Karol Ablow and Dorothy Thompson, as well as Peter Schlessinger and Almitra Stanley, for their contributions to the collective reevaluation of this important artist.

This exhibition and accompanying catalogue have received significant encouragement from Boston University staff, faculty, and alumni. We are grateful for grants from the Humanities Foundation of the College of Liberal Arts and Graduate School at Boston University and to the Jewish Cultural Endowment of Boston University for supporting this catalogue. We extend special thanks to Jon Westling, Executive Vice President and Provost; Bruce MacCombie, Dean of the School for the Arts; Stuart Baron, Director, Visual Arts Division; to Joseph Ablow, Sidney Hurwitz, and Carol Keller, faculty members in the Visual Arts Division; Keith N. Morgan, Chairman, Art History Department; and Caroline Jones, Assistant Professor, Art History Department. Our deepest gratitude goes to Joseph Ablow for his introduction to the transcript of his 1966 dialogue with Philip Guston, his thoughtful efforts at editing the transcript, and for his reminiscences of Guston. We also wish to acknowledge the efforts of the students in the curatorial seminar offered this spring, that was devoted to Philip Guston's late work. These students were responsible for transcribing the interview and writing many of the catalogue entries. They are: Elizabeth Boggess, Marina Chotzinoff, Martha Frellsen, Jean Graves, Yoshiko Hikida, Blake Morandi, Wen-jui Huang, Anja Rauh, Russell Roberts, and Tamaki Saito. Special thanks are due to Karen Georgi for her assistence in the production of this catalogue, and to Olive Pierce and Sally Abugov for their editorial and design expertise.

In compiling material for this catalogue, a number of Guston's colleagues and former students allowed themselves to be interviewed. We wish to thank artists Phyllis Berman, Robert Ganong, and Jon Imber for their vivid memories. Finally, we extend our appreciation to the poets for their participation in readings at Boston University Art Gallery and at the Addison Gallery of American Art. They include: Bill Berkson, William Corbett, Clark Coolidge, Stanley Kunitz, and Geoffrey Young.

This exhibition is an homage to Philip Guston's artistic vitality and his ongoing legacy to Boston University.

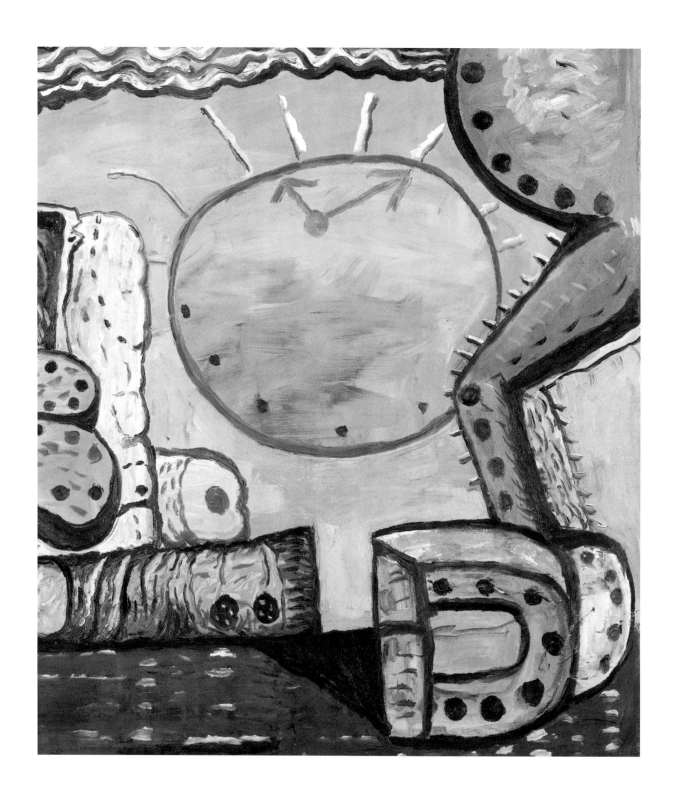

Figure 1

*To I. B.* (detail), 1977

Oil on canvas, 67 ¼ x 80 in. (170.8 x 203.2 cm.)

The Estate of Philip Guston, Courtesy McKee Gallery, New York

# GUSTON'S PRIVATE AND PUBLIC BATTLES

Mary Drach McInnes

*No one knows it—but right here in the woods—I feel like Lenin or Trotsky—in Zurich, plotting the revolution!—I say battlegrounds—Yes, the battle—conflict—now is showing—it's all in the open now—we are in the arena—exposed—* . . . Pots of paint shown—with dozens of brushes as weapons stuck in, in real—real—*conflict—fighting off—with weapons—*shields not garbage cans—*fighting the abstract part of art—the not visible—Oh so that's it—the conflict against the real against the unreal. My God! The things that do not go together—and won't—must—and yet they do! I was not prepared yet—until now!*[1]

*Philip Guston, September 1978*

In correspondence written late in his life, Philip Guston casts himself as a revolutionary, engaging in what he called "the conflict against the real against the unreal."[2] The artist's martial rhetoric is pervasive and significant. "Battle" describes both the struggle *within* his painting and the combative narratives *of* his painting. Within each canvas, Guston's gritty, burlesque imagery threatens to undermine the formal order of the picture. This contest between the subject and the plastic form was crucial to his work.[3] It led to his startling, often enigmatic, narratives that center on conflict.

*Philip Guston, 1975–1980: Private and Public Battles* explores the narrative conflicts that captured the imagination of the painter. Despite his declining health, Guston worked intensely during this period, further transforming his figurative art. He rid his work of Krazy Kat dramas for an intimate and finally more iconic vision of the human condition. Two major battlefields appear in the artist's late work: the private studio in which Guston struggles with his identity as an artist and the public field in which he makes visible his meditations on war and aggression. Guston's private conflicts in fact collide with his brutal narratives. The artist populates his canvases with figures that alternate between autobiography and history. His icons contain personal and collective meanings; they conflate feeling and memory, literary prose and political events. These multivalent symbols create layers of differing and at times competing texts on the picture plane. Yet the artist's individual struggle is the starting point for all his narratives.

Guston dramatically stages his personal battles in his late paintings. His studio images depict the artist's struggle with the act of creation. Guston's stated goal in painting was to achieve the miraculous—to create breathing, pulsating organisms.[4] He purposefully shrouded the act of painting in religious terms and saw himself in multiple roles: as the Creator, the created, and the fallen. The artist portrayed his godlike power, positioned himself as a new Adam, and described his painting as "devil's work."[5] Guston used these diverse roles to enact his conflicted relationship with painting. In his studio narratives, the artist perpetually battles himself and his creations.

The act of painting and its attendant struggle are presented in Guston's studio imagery of the 1970s. Like many of his generation, Guston viewed the studio as a field of contest.[6] His paintings show both the physical reality and the psychological drama of the studio. An assortment of brushes, canvases, and globs of paint signify the artist's workplace. This mundane reality is offset by an iconography that divides along a sacred/profane line. Studio lamps and the hand of God symbolize inspiration; brick walls and upturned ladders represent barriers to this divine state. Disembodied heads, similar to the artist's profile, personify Guston's own creations; bloody fists, derived from Piero della Francesca's *The Flagellation* (c. 1455), embody the artist's "passion." These figures reveal the artist's personal conflict. In such works as *Yellow Light*, Guston constructs the studio with all of its props and phantoms and portrays his private feelings—his awe and fear of painting.

The continual and pervasive violence of Western civilization appears in Guston's public narratives. In the late seventies, the artist's philosophical meditations on war were translated into pictorial images drawn from literary texts and political events.[7] In his large-scale canvases, the artist assembles a set of disturbing icons to convey the brutality of war: severed limbs, mechanical horses, and animated shields. Many of his paintings transcend the particular in search of a timeless quality. His work alludes to such classical themes as retribution and justice. Even these epic narratives, however, are filtered through the personal lens of the artist: his "blockhead" profile represents the damned (*Division*); his parents' birthplace is a scene of carnage (*To I.B.*). Guston's images of war are always steeped in his biography. As victim or violator, he commanded the center of his narrative battles.

*Yellow Light* (1975) (plate 1) is Philip Guston's allegory of the artist's studio, the embodiment of his private sphere. The upper half of the canvas is crowded with Guston's self-portrait, several effigies, and objects representing the act of painting. The artist is passive—pale, warm colors of gray, ochre, and salmon pink outline his profile. A large pink iris stares out to the right. Guston faces not just one nemesis, but four. The "blockheads" consist of a large forehead and giant eye. These misshapen cyclopes, comic and terrifying, demand our attention with their ominous physical presence. One confronts the artist and has a particularly threatening nature; his gaze impacts and indents the artist's self-portrait,

while his shadow spills over into a pool of blood. These "cephaloids," as Robert Zaller calls the figures, are central to Guston's narrative, orchestrating and personifying the drama of the studio.[8] Their gaze directs the action of the narrative: one confronts the artist; two hover overhead, staring at a hanging lamp; another glances down at the empty field of the canvas. Clustered around Guston's self-portrait, these cephaloids envelop and suffocate the artist, reflecting his insecurities.

In *Yellow Light,* Guston assembles a group of objects that highlight his personal struggles within the studio. An upended brick wall looms directly behind his head. The thickness and density of the masonry contrasts with the artist's pale portrait. The structure, a palpably heavy form, boxes the artist into a confrontation with his creations. Next to the wall stands a ladder, symbolic of movement from one physical or metaphorical space to another. Its overturned form offers a further chaotic element to the drama. Below the ladder is a bloodred fist. Like the wall, this fist has a strong visceral quality. An icon of violent action and oppression, the fist's presence completes the front-line of the studio battle.[9] The three elements—dense wall, upended ladder, and bloody fist—are the artist's personal motifs for the conflict that surrounds the creative act.

Set against Guston's fearsome objects of terror are the light of reason and the hand of inspiration. These positive icons are drawn from cartoon conventions and religious iconography. Hanging above Guston's head is a light bulb, a standard comic-book symbol of an idea. To the right, light emanates from a partially erased lamp. Underneath, a disembodied hand imitating the hand of God points to the light. Guston, who closely studied Renaissance painting, uses this sacred image to indicate the divine moment of creation. These symbols of inspiration counter the torment of the artistic struggle.

*Yellow Light* participates in a dialogue between piety and blasphemy as it presents, then subverts the godlike power of the artist. The misshapen cephaloids are a monstrous affirmation of the artist's creative ability and the consequence of his "devil's work." The drama in *Yellow Light* parallels the Jewish legend of the Golem. Art historian Robert Storr identified the importance of the Golem as a metaphor for creation in Guston's late work. The Golem, a human effigy sculpted from clay, was part of cabalistic rituals dating from the Middle Ages through the nineteenth century. It was a reenactment of the creation of Adam by God. Made by rabbis, this ritual broke the taboo of making idols; it was both a sacred and sacrilegious act. As Storr states, "In a culture that prohibited graven images as a usurpation of God's power to make living things, the Golem thus represented both an act of faith and an act of hubris."[10] Guston's allegory of the studio is similarly conflicted. The creation of a living being out of what Guston referred to as the "colored dirt" of paint mimics the formation of the Golem.[11] The Golem fascinated Guston, and in *Yellow Light* the artist confronts the terrifying consequences of his actions.[12] Here, his own imperfect creations are graven images, the cyclopean heads affirming and defying the artist's divine power.

The compressed figurative drama of the artist's studio in the upper section of *Yellow Light* is balanced by a field of paint in the lower half of the canvas. Guston's characters and props rise above a broad, painterly wash of pastel hues. The bare canvas and the lush quality of paint are accentuated. The "yellow light" of the title is smudged across the bottom edge. Visually and metaphorically representative of the palette table or artist's canvas, this zone mediates between the external space of the studio and the internal world of the artist. Guston gives us the physical reality of canvas and paint. The field becomes a site of transformation where new living beings will be animated by the artist's hand, the clay from which the Golem is formed. Painting, however, does not seem to redeem Guston, it only leads him to further struggle and confrontation.

In *Division* (1975) (plate 2), the studio displays the artist's personal interpretation of a deluge. The painting splices together the private drama of the artist with historical events and biblical apocalyptic imagery. The title is significant—the canvas is divided formally into horizontal registers and thematically into competing narratives. A painter's table and canvas occupy the lower half of the composition; the upper section is filled with the artist's vision of a flood. Both registers form a single entity formally knitted together by color, spatial organization, and structural form. The table, painted in a monochromatic range of cadmium reds and pinks, holds thin brushes, a small tin cup, and oval discs of pigment. The orderly workbench, which contrasts dramatically with Guston's own messy painting technique, represents the physical site of the studio. The painting table is the support for, and origin of, Guston's inner vision.

Over the painting table in *Division* is an apocalyptic image of a flood. The deluge, a theme that Guston explored repeatedly during this period, is pictured here as a vast red seascape filled with the detritus of the artist's life. Heads, shoes, and books float in the waves. This watery field is in flux—a head transforms into the sole of a shoe; text slips into the pattern of the wave; his wife Musa's profile becomes a page of a book. The partially submerged heads represent the artist and offer an autobiographical text for the painting. He is shown unmoored, cast out to sea with his wife and belongings. The position of this imagery over a painting table reinforces this reading. In fact, we witness the spiritual drowning of the artist.

The essentially private narrative of this painting reaches into the public arena for larger historical meanings. The deluge imagery of *Division* stems from Guston's illustration work during World War II. In 1943, the artist was assigned to depict scenes of United States Naval rescue missions and air training programs. A drawing of flotation exercises, which appeared in *Fortune* magazine, shows a group of men practicing lifesaving methods in the water.[13] Thirty years later, their disembodied heads and inflated life preservers reappear in *Division*. The image of a lifesaving drill has been transformed into a vision of drowning. The wartime origin of this imagery hovers behind the personal imagery of Guston's bean-headed profile and bulbous shoes. In *Division*, the autobio-

graphical alternates with the historical; the drowning artist now reads as a casualty of war.

Guston's spiritual drowning also reflects the biblical Deluge. The artist, who referred to his deluge series as "end of the world paintings," evokes the Old Testament scripture of Noah.[14] He alludes to Renaissance apocalyptic images—paying special homage to Paolo Uccello's *The Flood* (c. 1445).[15] Uccello, one of Guston's favorite Renaissance artists, depicts the story of Noah in a lunette in Santa Maria Novella. This Florentine fresco, which Guston likely saw during his extensive travels in Italy, is an explosive perspectival image of the ark and the Flood. Formally, Guston borrows its monochromatic palette, changing Uccello's golden hues to his fleshy, cadmium-red tones. Thematically, he substitutes his own head for the images of the damned. In *Division*, Guston filters Old Testament text through his personal lens. Again, the artist self-consciously points to himself, to his studio, and to the act of painting.

While Guston selectively depicts, alters, and personalizes biblical narrative, he absorbs Uccello's ability to bring the extraordinary into the limits of perspectival reality. Crammed within the confines of Uccello's lunette are the ark, Noah, the Deluge, lost souls, and God descending from a cloud. Here, spectral figures are fully and dramatically rendered. This merging of the real with the visionary consistently fascinated Guston. The fantastical imagery of Uccello, as well as the modern painting of Giorgio de Chirico, had engaged him since his youth in Los Angeles. In *Division*, Guston himself splices two sets of competing realities—the artist's palette and the artist's vision that arises out of it—into a single canvas.

The strange and the familiar also collide in Philip Guston's *To J.S.* (1977) (plate 5). The painter engages the public realm of surrealist literature as he progresses from biblical text to modern prose. This seascape, an homage to the French surrealist poet Jules Supervielle, shows four bent legs and hooves emerging over the horizon. Guston's metamorphic image is based purely in the dream-realm. The legs are iron gray in color and dotted with rivets. Protruding out from the limbs are black hairs, also endowed with a metallic quality. This disturbing image, which seems to borrow its shape from giant insect movies, is depicted with startling clarity and childlike simplicity. Flat colors fill in the forms, at times spilling over the thick, black outlines. The creature—mechanical horse, science fiction tarantula, or animated building crane—straddles the tilted horizon line. The ocean, a flat panel of ultramarine blue pigment, acts as a bridge between our reality and Guston's dream world.

Guston's range of images in his late work—his apocalyptic visions, his burlesque figures, his pictorial punning—drew on the work of surrealist writers. The artist was inspired by French surrealist poetry, although he found surrealist painting to be formulaic. He was fond of quoting Louis Aragon's line, "The vice called surrealism is the immoderate and passionate use of the drug which is the 'image.'"[16] Surrealist writers attempted to tap into the unconscious and worked with an incessant flow of dream images. Within

the dream world, fantastic, erotic, and violent images clashed with reality. What was deemed unlikely or impossible became probable and possible.[17] Guston appropriated the surrealists' tremendous range of images, their breakdown of thematic and structural conventions regarding the use of these images, and their pairing of the extraordinary with everyday reality.

*To J.S.* borrows Supervielle's formal structure and thematic concerns. Like Guston, Jules Supervielle (1884–1960) combined dream imagery with direct observation in a deceptively simple manner. Supervielle, who worked on the "fringes" of surrealism, connected more surely with the natural world than did the closest associates of surrealist leader André Breton.[18] Supervielle's ability to capture an elusive part of reality in a few well-chosen words and phrases captured Guston's imagination. Guston owned a copy of Marcel Raymond's book on modern French writers, in which Supervielle's poems are noted for their gravity and his prose for taking "form slowly in the twilight, like a gray image in an unsilvered mirror."[19] Raymond might almost have been describing Guston's paintings, also clearly rendered yet chimerical.

*To J.S.* parallels the poet's spare style. It seems to directly reflect one particular poem by Supervielle, "*Les Chevaux du Temps*" ("The Horses of Time"). The first lines read:

> When the horses of Time are halted at my door
> I am always a little afraid to watch them drink
> Since it is with my blood they quench their thirst.[20]

Guston's canvas offers an extraordinary creature similar to those in Supervielle's poem. (See catalogue entry for full text.) Both men endow their work with a violent undercurrent. In the poem, Supervielle offers a vulnerable portrait of himself, one threatened by death. These haunting creatures, who drink the narrator's blood, personify the passage of time. Guston similarly gives us a creature that defies nature. Our inability to read its identity, its motive, or even its movement disturbs us. The unnatural description of the figure accentuates our discomfort; its disconnected legs, naillike hairs, and riveted joints are not part of any conventional reality, but emerge out of the artist's imagination. Seemingly, only the sheer will of the artist holds this fantastical image to the canvas.

Guston shifts from the surrealist drama of *To J.S.* to public atrocity in *To I.B.* (1977) (plate 6). The artist addresses political events and social concerns; war and death are presented here. Still, the artist sifts these public battles through his own biography. *To I.B.*, dedicated to the Russian short story writer Isaac Babel (1894–1941), builds on Guston and Babel's common Russian Jewish background. It is one of Guston's most specific narratives. Three figurative elements form its composition: to the left, a severed penis lies atop a pile of fingers and legs; to the right, a mechanical horse flees the scene, his tail flying horizontally above the human debris; between these two figures, a luminous outline of a sun contains the hands of a clock. In the bloodred field, the word "Odessa" is prominently displayed.

"Odessa" becomes a keyword in Philip Guston's *To I.B.* As the birthplace of Guston's parents, as well as Babel's home, "Odessa" is a symbol of their common Russian Jewish heritage. Babel's Jewish identity and his relationship with the Cossacks has been a central focus of scholarly studies.[21] As a correspondent assigned to the Soviet Cavalry during the 1920 Polish Campaigns, Babel aligned himself professionally with the same Cossack soldiers who routinely brutalized Jews. Babel's endorsement of the Cossacks is clearly reflected in his own words: "What is our Cossack? Layers of tartness, daring, professionalism, revolutionary spirit."[22] The author hid his Jewish background, and the tension engendered by his identity as a Jew within Cossack society is central to his writing. Babel's double identity imbues his writings with a particular poignancy.[23] Likewise, Guston concealed his Jewish identity, changing his name from Goldstein to Guston during the Depression. This deception, which he still carried into the late seventies, caused the artist greater and greater discomfort.[24] In his painting, this personal drama lies beneath the brutal image of war.

*To I.B.* draws its narrative, its dramatic impact, and its formal structure from Babel's *Red Cavalry* tales, a collection of thirty-five impressionistic pieces reflecting the author's experiences with the Cossacks.[25] Babel's terse stories blind the viewer with their searing accounts of brutality. The *Red Cavalry* tales display the senselessness of military action, the despair of the survivors, and the indignity of death. Guston appropriates Babel's brutal images for his own canvas. *To I.B.* accentuates the horror of the victims in the anonymous, severed body fragments. Legs, inverted and planted in a bloody field, convey the image of an ignoble death. The cut phallus, a nightmare fragment symbolic of genocide, lies limply on top of this "crop." Guston shows us a bloody, haphazard butchery.

The formal dislocation and thematic dismemberment of Guston's paintings echo Babel's sensationalist journalism. The writer's rendition of local episodes leaves the reader with a shocking sense of brutality—a brutality whose senselessness is accentuated by the calm, deliberate voice of the narrator. One of the most potent tales in the Red Cavalry cycle is "Prishchepa's Vengeance," the story of a young Cossack who returns home and slaughters his neighbors in bloody retribution for his parents' death. (See catalogue entry for text.) Prishchepa's grotesque acts are recorded, their brutality underscored by the Cossack's methodical nature. The shock of his actions are compounded by the silence of his village as they watch his personal campaign of vengeance. The painter's own tale contains equally devastating elements—decaying limbs, upended legs, and cut penis. Severed and stacked, the victims are left behind without any identity, reduced to a refuse pile.

The boldly constructed narrative of *To I.B.* also shares the formal precision of Babel's own texts. Like Babel, Guston was interested in the punctuation of his work. To express his own formalist concerns, he would often quote Babel's remark, "There is no iron that can enter the human heart with such stupefying effect, as a period placed at just the right moment."[26] *To I.B.* frames and freezes the action. The painter focuses our attention onto

the most brutal elements of the battle. Guston's bold use of color adds to the visceral quality of *To I.B.* A primary palette of cobalt blue and cadmium red, accented by black and white, lends an elemental quality to the canvas. Red denotes the blood dripping off the severed limbs and the blood-soaked ground.

Guston's narrative transcends Babel's accounts of the 1920 Polish campaign and depicts the alienation of modern warfare.[27] An iron-gray horse gallops out of the canvas (fig. 1). Rivets encircle its hind quarters; naillike hairs bristle on end. A rear hoof turns and visually kicks us in the face. This mechanical creature replaces the noble steed of the Cossacks. Guston updates Babel's warfare, adding a more efficient and more terrifying technology to his battle.

*To I.B.* is a conflation of the public and private battles that Guston fought late in his career. Guston gives us an episode inspired by Babel's literary texts—a glimpse into the martial campaigns of the Soviet Cavalry shortly after World War I. The painter's image adds a more modern element to the brutality. The refuse pile of human limbs evokes both the death camp images of World War II and the then-current reality of Vietnam.[28] Guston, who lived through two World Wars, the Korean conflict, and actively opposed the Vietnam intervention, paints an image that symbolizes man's continued aggression. Time shifts forward and backward in *To I.B.* The word "Odessa" on the canvas, along with the circumcised penis, broadens the reading to include the Russian pogroms against the Jews at the turn of the century. The canvas thus becomes a text on the anti-semitism witnessed by Babel and felt by Guston. These historical and contemporary texts join the artist's personal struggle for his identity as a Jew. *To I.B.* marks Guston's ability to splice together his private conflicts with his public ruminations.

In *Aegean* (1978) (plate 7), Guston carves an iconic image of human brutality out of the picture plane. No longer representing a specific literary text or historical event, this image is a general outcry against all violence. One of Guston's last paintings, this canvas presents a mythical battle. A chain of fists and shields runs the length of the canvas and hovers over a barren field. Its panoramic scale (the canvas is 126 inches long), windswept plain, and powerful imagery portray a primordial battleground. The title, "Aegean," directly refers to the ancient cultures of the Mediterranean and indirectly evokes the Homeric tales of epic battles. The elemental nature of human violence is visible in the five arms and shields in *Aegean*. While each has a simplified, elongated shape, individual limbs describe different biological entities and evolutionary states ranging from savage to civilized. Two arms thrust out from the right side—one is a white, ossified appendage, the other, a club-like form suggesting an animal's limb. In contrast to these, the flesh-colored left arm wearing a wristwatch is the arm of contemporary man. Emerging out of its shield, a thick, red fist clutches a shield, which extends into another arm and shield. As smaller arms arise from larger units, the violence continues and multiplies. The phallic form of the arms expresses their virility and primal nature. Here, violence begets violence.

Guston's brutal image is further charged by the explosive nature of the shields, whose complementary and clashing colors contrast with their bulbous and malleable forms. They are at once filled with the sound of the battlefield and unexpectedly devoid of any tensile strength. The image of the arm and shield is Guston's hieroglyph for violence. Drawn from street scenes of childhood play and epic battles of Renaissance painting, it appears in some of Guston's earliest paintings. In the 1930s, he depicted boys fighting with scraps of lumber and ashcan lids. Typically, as in *The Gladiators* (1938), the artist portrays two youths locked in a circular motion. This image derives from Guston's memories of Renaissance battle paintings. In particular, the composition echoes the two foreground combatants in Piero della Francesca's *The Victory of Heraclius over Chosroes* (c. 1460). Piero, one of Guston's artistic touchstones, endows his victory scene with a static monumentality meant to convey the virtuous emotions of the combat.[29] In *Aegean*, Guston rids his image of childhood innocence and strips his battle of noble intentions. The figures are disembodied and reduced into a chain of violence. The action is in flux—there is no decision nor adjudication in this late painting. In *Aegean*, there is only conflict.

In the paintings of his last five years, Philip Guston presents us with his private conflicts as an artist and his public concerns as a man. This contest moves between the confines of the studio and the fields of war with its continued aggression. His confrontation in the studio becomes a metaphor for the timeless battles of the human spirit and for his own battle to continually reinvent his painting. Within each canvas, individual objects shift between autobiographical and historical references. Guston assembles a personal iconography and endows it with layers of meaning. His images are clusters of site, culture, memory, history, and emotion. These multivalent symbols form complex and, at times, competing texts. Guston, who forsook the easy and all too clear nature of contemporary art, stated that "art without a trial disappears at a glance."[30] In his late paintings, the contest is palpable. His narratives of the studio and of the human condition are heroic efforts to bridge the private and public spheres of life.

1. Letter dated September 1978 from Philip Guston to Ross Feld, quoted in Ross Feld, "Guston in Time," *Arts Magazine* 63 (November 1988): 43.

2. Ibid.

3. In Blackwood's film, Guston discusses the "cruciality . . . of the contest between the subject and the plastic form." See: Michael Blackwood, *Philip Guston: A Life Lived* (New York: Michael Blackwood Productions, 1981).

4. Guston often referred to the idea of creating a living being in the studio. His ideas on this are found in the 1966 "Conversation between Philip Guston and Joseph Ablow" transcribed in this catalogue.

5. Ibid.

6. Caroline Jones discusses the essentially Romantic construction of the studio among Guston's generation of Abstract Expressionist painters. See: Caroline Jones, "Machine in the Studio" (Ph.D. dissertation: Stanford University, 1991), 1–71.

7. In his youth, Guston was a political activist. He attended meetings of the John Reed Club and assisted in painting frescoes of the Scottsboro boys trial in 1931. Guston's Marxist ideas were nourished by the Mexican mural movement. He became familiar with the local work of David Alfaro Siqueiros and José Clemente Orozco. In 1934, he and Rueben Kadish traveled to Morelia, Mexico, and with Siquieros's support, they received a commission to paint a mural depicting *The Struggle Against Terrorism*. See: Alison de Lima Greene, "The Artist as Performer, Philip Guston's Early Work," *Arts Magazine* 63 (November 1988), 56.

8. "Cephaloid" is the term that Zaller uses to refer to Philip Guston's peeled heads of the late seventies. See: Robert Zaller, "Philip Guston and the Crisis of the Image," *Critical Inquiry* 14 (Autumn 1987), 88.

9. Rickey discusses the repeated use of these props in Guston's late work. See: Carrie Rickey, "Twilight's Last Dreaming: Philip Guston 1969–1980," in *Philip Guston, Retrospectiva de Pintura* (Madrid: Centro de Arte Reina Sofía, 1989), 164–165.

10. Robert Storr, *Philip Guston* (New York: Abbeville Press, 1983), 60.

11. Morton Feldman in Guston file, Library of the Museum of Modern Art, New York, quoted in Storr, 60.

12. Philip Guston, "Philip Guston's Object, A Dialogue with Harold Rosenberg," *Philip Guston, Recent Paintings and Drawings* (New York: The Jewish Museum, 1966), n.p.

13. Storr, 112.

14. Guston, "Philip Guston Talking," 54.

15. Ibid. Dore Ashton relates Guston's deluge imagery to his memories of Renaissance painting, particularly of Signorelli's portraits of Hell. See: Dore Ashton, *A Critical Study of Philip Guston* (Berkeley: University of California Press, 1976), 188.

16. Ibid., 179.

17. Marcel Raymond, *From Baudelaire to Surrealism* (London: Methuen & Co., Ltd., 1970), 262.

18. Ibid., 290.

19. Ibid., 309.

20. Jules Supervielle, *Selected Writings*. Trans. James Kirkup (New York: New Directions Publishing Corp., 1967), 42–43.

21. Babel's relationship with the Cossacks has been a central issue for literary scholars dealing with the Russian writer. Lionel Trilling, in his groundbreaking essay, asserts that Babel saw the Cavalry as "noble savages," and was trying to come to terms with the Cossack ethos. This notion is challenged by Harold Bloom, who

sees Babel as engaging in a more subtle form of Jewish irony. See: Lionel Trilling, "Introduction," in Isaac Babel, *The Collected Stories,* Ed. and trans. Walter Morison. (New York: S. G. Phillips. 1994), 9–37; and Harold Bloom, "Introduction," in *Isaac Babel* (New York: Chelsea House Publishers, 1987), 1–8.

22. James E. Falen, *Isaac Babel, Russian Master of the Short Story* (Knoxville: The University of Tennessee Press, 1974), 194.

23. In describing his Ku Klux Klan portraits of the late sixties and early seventies, Guston drew on Babel's experience as a Jew within the Soviet Cavalry: "In the new series of 'hoods' my attempt was really not to illustrate, to do pictures of the KKK, as I had done earlier. The idea of evil fascinated me, and rather like Isaac Babel who had joined the Cossacks lived with them and written stories about them, I almost tried to imagine that I was living with the Klan. What would it be like to be evil? To plan and plot." See: Guston, "Guston Talking," 52.

24. According to his daughter, Guston's motives for changing his name are unclear. She says: "Later, deeply ashamed of his act, my father concealed his name change, and asked his biographer Dore Ashton to avoid any reference to it in her book. He even went so far as to repaint the signatures on some of his early paintings." See: Musa Mayor, *Night Studio, A Memoir of Philip Guston by His Daughter* (New York: Penguin Books, 1988), 21–22.

25. Falen, vii.

26. Trilling, 15.

27. Guston's involvement with martial themes goes back to the 1930s when he did a number of compositions involving street fighting. During and immediately after World War II, the artist did a series of paintings that incorporate Beckmann motifs and Crucifixion imagery into disturbing narratives that express the tragedy of the Holocaust. See: Greene, 59.

28. Stephen Green, a former student of Guston's and a colleague of his at St. Louis, recalls that the revelations of the concentration camps shortly after World War II haunted Guston. Guston later stated that seeing the early pictures of Nazi death-camps caused him to leave his childhood narratives of the late 1940s. See: Greene, 59.

30. J.R. Hale, *Artists and Warfare in the Renaissance* (New Haven: Yale University Press, 1990), 157–158.

31. Philip Guston, "Faith, Hope and Impossibility," *Art News Annual 1966* 31 (October 1965), quoted in "Statements by the Artist," *Philip Guston* (San Francisco: San Francisco Museum of Modern Art, 1980), 42.

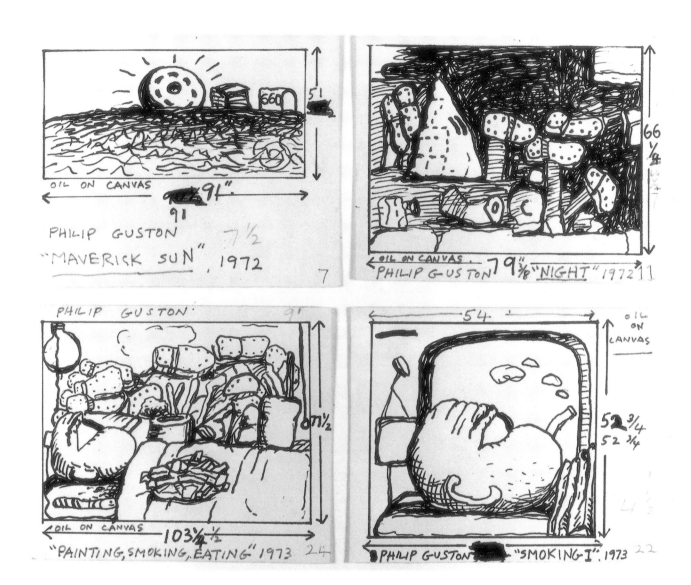

FIGURE 2

*Four Studies after Paintings: "Maverick Sun;" "Night;"*
*"Painting, Smoking, Eating;" "Smoking I ,"* 1974
Pen and ink on paper, 4 x 5 in. (10.2 x 12.7 cm.)
Collection of Sidney Hurwitz

# PHILIP GUSTON AT BOSTON UNIVERSITY

## Kim Sichel

Philip Guston's long and complex association with Boston University resonates with the force of an explosion, and the effects are felt even today. The dialogue between this dynamic painter and the Boston University community began with the honorary doctorate he was granted in 1970 and lasted through his final illness. In 1970 and again in 1974, Guston's new figurative work erupted on the New England scene with two monographic shows at the Boston University Art Gallery, then called the School of Fine and Applied Arts Gallery. He was an equally compelling presence as a teacher, first as a University Professor from the autumn of 1973 until 1978 and then as a Professor Emeritus from 1978 until his death in 1980. Most memories of him include his monthly arrivals in Boston, bursting with ideas and conversation. In addition to the dynamism he brought to his teaching, Guston enjoyed exchanging ideas and engaging in long nights of talking, not only with students but also with colleagues such as Joseph Ablow and David Aronson. Most remember Guston as a mythic energetic figure, exhausting in both his enthusiasms and his dislikes, but always fascinating.

Guston's time in Boston coincided with a period when his figurative works were receiving a very hostile reception in New York. In contrast, Boston University offered several tangible benefits to the painter: public recognition, intellectual companionship, and a teaching forum for talking about figurative painting.[1] With the support of an old friend, David Aronson of the School for the Arts, he received an honorary doctorate from Boston University in the spring of 1970, a clear sign of respect in the difficult year when he first exhibited his newly figurative work at New York's Marlborough Gallery. School for the Arts professor Sidney Hurwitz recalls a conversation with the artist at the dinner after he was granted his honorary degree. Guston explained that his work had changed, and that he did not know what kind of reception it would get. Hurwitz remembers his clear statement that he was committed to "putting content back into his imagery," and he recalls Guston's hope that his new work "would influence younger painters."[2]

Later that spring, Hurwitz visited the Marlborough Gallery exhibition to choose works for the planned Boston University show, having seen and read nothing of the new work but Hilton Kramer's devastating review, "A Mandarin Pretending to be a

Stumblebum," for *The New York Times*. Meeting Guston in the gallery, Hurwitz was completely nonplussed by the paintings, but he and his colleagues trusted the painter's intellect and instincts. Guston asked, "Do you still want the show?" Hurwitz replied, "Of course."[3] *New Paintings: Philip Guston* opened at the Boston University Art Gallery in the autumn of 1970.

Another large exhibition of post-1970 work, *Philip Guston: New Paintings*, opened at the Gallery on March 15, 1974, soon after his appointment as a University Professor. This show was organized by John Arthur, then Director of the Gallery, and by Sidney Hurwitz. Guston made postcard-sized sketches (fig. 2) of each painting in the show, and juggled them repeatedly as he agonized about the layout of the exhibition, often rehanging the show. A large opening reception was attended by Musa Guston, Musa Mayer, Guston's new dealer, David McKee, Philip Roth, and many New York friends. In her memoir of her father, Musa Mayer quotes David McKee's comment to her that evening, "The new work is difficult. Very demanding. But they will eventually come around. In the end, your father will be recognized as one of the great painters of this century."[4]

The 1974 opened with a symposium with critic and longtime supporter Harold Rosenberg. The transcript records Guston stating, "In my mind, this show catches me in flight. It's really about paintings, paintings about the painter."[5] Although the new paintings had a mixed reception even in these years, Robert Taylor, art critic for *The Boston Globe*, perceived the connections between the Abstract Expressionist work and the representational work. Taylor disagreed with Rosenberg's assessment that "Action painting is not about anything, while Guston's [Klan] paintings are," seeing instead a creative use of doubt and tension in both earlier and current work.[6] Taylor writes:

> Neither the formal and balanced nor the anti-formal and chaotic prevail, however, which strikes me as the keynote of the work: doubt . . . . Just as the process of repainting and erasure in his nonrepresentational works conveyed the mechanics of it, so the ambiguities of the BU show project the complexities and uncertainties which can destroy the artist, or become a principle that deepens vision.[7]

During Guston's years in Boston, the faculty and students at Boston University offered him a chance to explore ideas and conversations during a time when he was alienated from the New York painting world. All those who knew him in Boston recall his energy both for teaching and for talk. Guston first arrived as a visiting critic in the spring of 1972, and with faculty member Joseph Ablow's urging was appointed a University Professor at Boston University beginning in the autumn of 1973. In between his intensive monthly three-day teaching sessions, he worked in his Woodstock studio. This arrangement suited the painter, whose teaching at the university coincided almost exactly with the most active years of his entire career. As his daughter Musa Mayer writes:

The stretch of years from 1974 until the time of my father's first heart attack, in March of 1979, was by far the most productive of the entire fifty-year span of his career. Dozens of huge canvases took shape on his wall—so many, finally, that he had to have another cinder block addition to his studio built to contain them. "They don't seem to be pictures anymore, but sort of confessions—exposures," he wrote.[8]

The excitement of studying with a painter "mad with painting," as Joseph Ablow has described him during these years, was one of the most important legacies he left his students.[9] In Boston, Guston often spent evenings with friends, talking constantly until the early hours of the morning. Most colleagues from these years agree that he was always churning with things to say, and the literary conversations ranged widely, from Flaubert to Pater. Ablow remembers him "like an ancient mariner when he came."[10] Poet and friend William Corbett recalls Guston's arrivals in Boston as a time for, "coming up for air and talking a mile a minute."[11]

Intense talking and a passion for painting were the essence of Guston's teaching style. On his visits, Guston would spend days visiting students' studios, focusing the same uncompromising energy—both positive and negative—on their efforts that he did on his own work. Although little has been written about Guston as a teacher, the role of teaching during these years was fulfilling for him. He clearly enjoyed teaching, stating somewhat satirically, "I've become Mr. Chips. I love it."[12] He participated in the selection of students for the program, he built upon the figurative tradition of the school, and he attempted to help all of the students.

During these years, as painter and former student Jon Imber puts it, Guston was "on a mission to reintroduce content into art," whether figurative or abstract.[13] Guston admired the strength of the then-unfashionable figurative tradition of the School for the Arts, and its relatively small size offered him an opportunity to spread his ideas. During these years when the New York art world was shunning his work, the location of the school was also appealing. Here was an audience with few connections to institutions and old colleagues in New York.

Guston's teachings and his paintings had a profound influence on a whole generation of painters graduating from the program, and his presence looms as a mythic collective memory in the School. Fifteen or twenty years later, Guston's former students remember the painter vividly, describing in detail his blue shirt, light trousers, and tremendously forceful physical presence (fig. 3). He is described as both overpowering and sometimes vulnerable, as if his own efforts to create painting anew with each canvas both lionized and leveled him. The struggle he constantly re-created in his own work made him aware of the struggle of others.

Guston's teaching and his legendary talking emphasized history, originality, and a

passion for painting. Despite his authoritative physical and artistic presence, Guston rarely discussed his own work, encouraging students instead to look at the entire history of art rather than simply modern art. Painter, former student, and teaching colleague Phyllis Berman recalls that he often said, "Don't look at me. Look at the painters I love," meaning Piero della Francesca, Chardin, Uccello, and de Chirico.[14] He would tour the students' studios, which at that time were scattered in various corners of the campus. Groups of painters would follow him, and listen to his comments. As Berman explains, he would "inflate" in front of one person's work one month, and another's the next.[15] Guston's criticism could be as overwhelming as his praise. Another former student, Robert Ganong, recalls that "He had an amazing visual memory for our paintings, and his Renaissance favorites. He would say: 'I thought about your painting,' and that was great."[16] The blast of enthusiasm drove the student to work feverishly for the next month until Guston's next visit.

Although he responded to students closer to his organic manner of painting, Guston attempted to assist any painter who was trying to discover his or her own completely honest expression. His contribution to a wide variety of students working in disparate styles seems to be the same lesson he strove to achieve himself. He continually sought to help students to find their own original voices and their own ways as painters, while avoiding the trap of succumbing to elegant style as a replacement for the creative process of painting. Ganong comments that "If there was a voice at all in the work, he responded."[17] And Berman recalls that Guston constantly told them, "I want to see something I've never seen before. I want to see something different."[18]

Guston taught not the nuts and bolts of painting technique, but passion: the painful and continuous struggle for a personal mission in painting. He disliked competent style as a veneer, searching in his students' work for a deeper creative process in each painting, whatever its style. He never accepted less than a total emotional involvement in his own work, and he held his students to the same standard. That passion underlies all aspects of Guston's experiences in Boston: his paintings as seen in the Gallery exhibitions; his friendships with poets, painters and students; and, above all, his complete commitment to teaching his own credo of originality and struggle. The Boston environment freed him to explore these emotions without the fetters of the New York art world, and the physical presence of that explosive energy is present here today.

NOTES

---

1.  These years at Boston University were certainly not Philip Guston's only teaching commitments during his later years, and his tenure here reflects his lifelong although sporadic teaching experiences. After his faculty posts at the State University of Iowa and at the St. Louis School for the Arts at Washington University, Guston taught in New York, as adjunct professor of painting at New York University from 1951 to 1958, and at the Pratt Institute from 1953 to 1958. After receiving a Ford Foundation grant in 1959, he taught only informally until his arrival at Boston University. He continued to work as artist-in-residence and guest critic, however, teaching during the 1960s at Yale University's Summer School in Norfolk, Connecticut, as artist-in-residence at Brandeis University in 1966, at Skidmore College in 1968, and as guest critic at Columbia University in the late 1960s and early '70s.

2.  Sidney Hurwitz, conversation with author, Boston, 24 May 1994.

3.  Ibid.

4.  Musa Mayer, *Night Studio: A Memoir of Philip Guston by His Daughter* (New York: Penquin Books, 1988), 169.

5.  Philip Guston, interview by Harold Rosenberg, March 1974, tape recording, Boston University, Boston. Much of the taped conversation is inaudible due to microphone malfunctions, and those who were present recall that the audience heard nothing of their exchange.

6.  Robert Taylor, "Guston: The Raw and the Refined," *The Boston Globe* (24 March 1974), A–12.

7.  Ibid.

8.  Mayer, 180.

9.  Joseph Ablow, conversation with author, Boston, 19 May 1994.

10. Ibid.

11. William Corbett, conversation with Mary Drach McInnes, Boston, 7 June 1994.

12. Joseph Ablow, conversation with author, Boston, 19 May 1994.

13. Jon Imber, conversation with author, Boston, 27 May 1994.

14. Phyllis Berman, conversation with author, Boston, 21 May 1994.

15. Ibid.

16. Robert Ganong, conversation with author, Boston, 21 May 1994.

17. Ibid.

18. Berman, conversation with author.

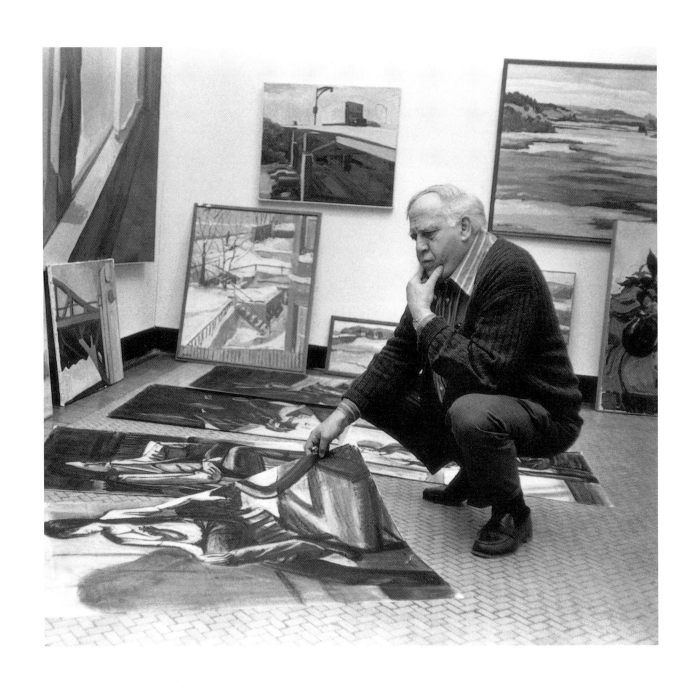

Figure 3

Philip Guston at Boston University, April 18, 1975

# A CONVERSATION BETWEEN PHILIP GUSTON

# AND JOSEPH ABLOW

## With a new introduction by Joseph Ablow

*In the spring of 1966, Philip Guston came to Boston University to speak to the students and faculty of the Division of Art.[1] This was the first of many talks that Guston would give at Boston University during the years that he was associated with us, but in many ways it was a singular event. Although we did not know it at the time, Guston was at the beginning of a critical period in his career; in retrospect, his talk offers a revealing glimpse into the thinking that was leading him to the extraordinary paintings of his last decade.*

*Unlike most painters, Guston often chose not to use slides of his work as the subject of his talks but to discuss the ideas that were the basis of his painting. Guston tussled with ideas with the same intensity that he tussled with images; for him it was all part of the same undertaking. My role was simply to provide a few questions for him to consider, and, as the reader will see, Guston needed only the briefest encouragement to offer extended and often brilliant meditations on his art and the art of others. However, because of what seemed to be evolving in his new work, I had prepared my questions with a rather specific focus. In 1966, Guston was considered to be one of the most important of the Abstract Expressionists, and his recent paintings, although harsher and weightier, seemed to represent a continuation and expansion of his earlier concerns. There were, however, hints that something else was going on. Heads, figures, objects—typically abstracted and simplified but legible—were becoming insistent and undeniable presences in the new canvases. The titles of the paintings—Table, Duo, The Scale, Actors, A New Place—and, more significantly, the images themselves indicated that Guston's work was changing. I wanted to get him to talk about this change.*

*Reading the transcript of his responses, one can see, possibly because he was still in mid-journey, that Guston appears reluctant at first to admit that any important shift from his earlier Abstract Expressionist thinking has taken place. However, as he gets caught up in an exploration of the nature of abstraction and figuration, he seems to grow more comfortable talking about his new concerns and about the need to evolve and even to change course. Compare, for example, the story about his failed studio interior with his memory of watching a couple of guys having a philosophical discussion, or with his description of the look of some cheap coffee cups.*

*It was not until 1970 that we were to know where this wrestling with the world beyond the canvas would lead him and us, but what we did experience that afternoon in 1966 was the extraordinary strength of will and subtle intelligence that informed Guston's life as a painter.*

JA: I want to ask you something that occurred to me as I went over your biography. Abstract Expressionism, or whatever it's called . . .

PG: I prefer the term New York School. I think the appellation [Abstract Expressionism] doesn't seem actual to me, it seems like a coined phrase. As a matter of fact, I don't remember in any of the get-togethers I had with the painters of that period, names of whom you probably know, when that word was ever used or exchanged. I mean nobody ever said," You so-and-so-Abstract-Expressionist-you." Imagine the "primitive" painter Henri Rousseau saying that he was going to make a "primitive" painting. As he said to Picasso, "You represent the Egyptian School and I represent the Realistic School."

I think there was something going on, of course, and every painter was different. I think it was a geographical thing. I happened to be there. If I hadn't been there, I don't know what I would have done. I think what made it a kind of group that met in each other's studios or in bars was a dissatisfaction with what had been going on or what each of us had been doing previously. It's as if you didn't know what you wanted to do, but you knew what you didn't want to do. It's very important to know what you don't want to do. Negatives can be very positive, very important. There was a sense of embarking on something for which you didn't know the outcome. Of course, the idea of having a career just didn't seem possible; it didn't seem possible that you'd ever make a living

out of it or that anybody would look at it. There were maybe two or three galleries showing that stuff [Abstract Expressionism] at the time out of sheer dedication to the idea. It is not the way it is now. Anyway, the term was coined like all terms . . . isn't that how all the other terms, "Impressionist" or "Cubist" were coined?

JA: I was going to compare Abstract Expressionism, which I'll now call the New York School, to Cubism, which I'll now call the School of Paris. The School of Paris had a life of thirty-five years, and we are being told by the critics and various media that the New York School is dead . . .

PG: . . . is dead . . .

JA: . . . and it was truncated after about sixteen or seventeen years. Considering the vitality and the purpose of the New York School, why do you think this happened, or has it happened?

PG: That's better. "Has it happened?," because asking why do I think this "happened" is like the "Are you still beating your wife?" question. You mean, "What's happening?" Is that what you mean? I have all kinds of ideas about that.

First of all, what I enjoyed about the New York School and the School of Paris was that everything was going on at the same time. You have to remember that while Picasso and Braque were painting what they were painting during the teens, one of the great painters of the century, de Chirico, was painting his masterpieces at the same time. Yet they were totally different. Soutine, a little later—another

giant in my mind—was painting what he was painting. Matisse was painting what he was painting. I prefer to think that the second generation of the New York School saw the work of the first generation as a manner in which they could comfortably work. In other words, in spite of all the imitators, each man is totally different. I see no connection between, say, Mark Rothko and [Franz] Kline. I think there has been so much jazz printed about the whole business. You know their names— they are always listed like, "Who was there at a cocktail party" . . . or something.

I think the original problems, that were posed after the war period [World War II] in painting, were the most, to my way of thinking, the most revolutionary problems posed and *still are.* In other words, nothing is dead. You can't put it under a rug and pretend it's gone. I think the reason for wanting it to die off, in terms of critics, dealers, museums—the establishment of the art world, officialdom, avant-garde officialdom, same thing as any other kind of officialdom—they saw the work of Abstract Expressionism as style, as a certain way of painting. Now if it's seen that way, then, of course, styles come and go. I mean, everybody gets sick of a certain style. After ten or fifteen years, you're bored sick of it. Younger painters come along and want to react against it. I think that was one of the motivations for trying to kill it off. It's dead. And then, of course, the American idea of change enters into it, like the idea of new emotions, new feelings, having to find new forms. All this is true. All that exists, and there's nothing wrong

with it. Yet I could not paint another minute in the way I do if I didn't believe that this was a revolution; it really was a powerful revolutionary instinct which *may* *it hasn't!* have lost its power, which may have lost its efficacy, in our current emotional climate. That's possible, but that can change. All right, now, what was this, this revolution? That's really the issue. What is it about? Because I think it's still current. *I do too —*

I think it's about, I know it's about and revolves around, the issue of whether it's possible to create in our society *at all* . . . . *great!* Whether one should not make pictures. Everybody can make pictures. Thousands of people go to school. Thousands of people go to galleries, museums. It becomes not only a way of life now, it becomes a way to make a living. In our kind of democracy this is going to proliferate like mad. In the next ten years, there will be even much more than there is now. There'll just be tons of art centers, and gal- *TRUE* leries, and pictures. Everybody will be *yes-unfortunately!* making pictures.

The real question is . . . . Painting and sculpture are very archaic forms. It's the only thing left in our industrial society where an individual alone can make something with not just his own hands, but brains, imagination, heart, maybe. It's a very archaic form. Same thing can be said with words, writing poetry, making sounds, music. It is a unique thing. Just imagine, ninety-nine percent of the people just report somewhere, are digits, go to an office, *How TRUE — How* clear a desk, get plastered, and then, they do *SAD.* the same thing the next day. So what is this funny activity you do? What is it?

I think that the original revolutionary impulse behind the New York School, as I felt it anyway, and as I think my colleagues felt and the way we talked all the time, was a kind of a . . . you felt as if you were driven into a corner, against the wall with no place to stand, just the place you occupied, as if the act of painting itself was not making a picture—there are plenty of pictures in the world, why clutter up the world with pictures—it was as if you had to prove to yourself that truly the act of creation was still possible. Whether it was just possible. It felt to me as if you were on trial. I'm speaking very subjectively. I felt as if I was talking to myself, having a dialectical monologue with myself to see if I could create.

What do I mean by create? I mean that the things I felt and that I enjoyed about certain painters of the past that I liked, that inspired me, like Cézanne and Manet, that thing I enjoyed in their work, that complete losing of oneself in the work to such an extent that the work itself, even though it was a picture of a woman in front of a mirror or some dead fish on the table, the pictures of these men were not pictures to me. They felt as if a living organism was posited there on this canvas, on this surface. That's truly to me the act of creation. It didn't at the time, for reasons that I don't completely understand myself. I still worry about it and puzzle about it, and I go two steps backward, because I'm puzzled by a lot of problems that I would not know how to begin talking to you [about]. These problems revolve around abstract painting or non-objective painting or image-making.

Of course, I'm seeking a place, an area, where these questions would be dissolved, where they don't exist, where somehow in me all this would come together. I mean that's my hope.

So as I was going to say, for reasons which I do not understand, [during] the late forties, early fifties, when I went into nonfigurative painting—although I felt I was even then involved with imagery, even though I didn't understand the imagery completely myself, but I thought it was imagery, and for some reason that's not quite clear to me yet, and maybe I don't want to be clear about it either—I was forced and pushed into the kind of painting that I did. That is to say that the demands [are] in this dialogue with myself. I give to it, I make some marks, it speaks to me, I speak to it, we have *terrible* arguments going on all night, weeks and weeks. Do I really believe that? I make a mark, a few strokes. I argue with myself, not "Do I like it or not?" but, "Is it true or not?" "Is that what I mean, is that what I want?"

There comes a point when something catches on the canvas, something grips on the canvas. I don't know when it is. You put paint on a surface, most of the time it just looks like paint. I mean who the hell wants paint on a surface? You take it off, put it on, it goes over here, it goes over a foot. As you go closer, you start moving in inches, not feet—then half inches. There comes a point though when the paint doesn't feel like paint, I don't know why, some mysterious things happen. I think you all experience this, maybe in parts of canvases. Maybe you can do it by painting

a face or an eye or a nose or an apple, it doesn't matter. What counts is that the paint should really disappear, otherwise it's craft or something like that. That's what I mean by something grips the canvas. The moment that happens, you're sucked into a kind of rhythm. I don't mean a dancing rhythm or action painting, I mean you are psychically sucked in, and this plane starts acquiring a life of its own. Then you're a goner. If you are lucky, you have a run of two or three hours, and you can't repair it, you can't fix it, and it feels like you've just made a living thing. All I can tell you is what it feels like.

I have all kinds of wonderful ideas: a little green there, a little blue there, I'll have this there, and you proceed to do it. Then you leave the studio, and it's like having a bunch of rocks in your stomach, you can't stand to see these illustrations of your ideas. Then all the trouble starts, the dissatisfaction starts, and you go back and scrape it out and you move it around. Then there comes a time, if you persevere long enough, when the paint seems alive, it is actually living, and there's some kind of release . . . where thinking doesn't proceed doing. The space seems to be shortened between thinking and doing. Most of the time what I really hate—yet, I have to go through it like a preparation—is the horrible sensation of you putting the paint on. It gets so boring to put paint on and to *see* yourself putting paint on. You're really preparing for those few hours where there's some kind of umbilical cord attached between you and it. You do it, the work is done, and this cord seems to slacken, then

you leave the studio and those rocks aren't there anymore. Then you can go to a movie in the afternoon—two movies— you feel okay, you don't have to feel guilty about anything, and you've left a living thing there.

One of the signs that I go by is that [when] I've left this thing there, I don't remember it, I don't remember what it looks like, I only remember the general feeling about it. But I don't remember parts of it. That's what I want—I don't want to be stuck with parts. I know I haven't finished a picture when I sit down to eat outside the studio and I think, "Gee, that's a pretty nice relationship between that part and that part." There has to be this peculiar kind of unity. Once you've tasted that or experienced that, it's hard to settle for anything else. I think it's kind of like devil's work, because you know man is not supposed to make life. Only God can make a tree. Why should you make a living organism? You should make images of living organisms, but it seems presumptuous to attempt to make a thing which breathes and pulsates right there by itself. It's unnatural in a way. The human way to create, I think, is the way we see—from part to part—you do this, and then you do that, and then you do that, and then you do that, then you learn about composition, and then you analyze the Old Masters and you form certain ideas about structure. You have to go from part to part, but you shouldn't see yourself go from part to part—*that's* the whole point—the rectangle is the world. I mean that's reality for those few minutes, hours; *that's* the world.

JA:   When you're working and you see something that reminds you of a literal image, how does this affect you?

PG:   I tussle with these things all the time. A few years ago, like I do quite often, I got very nervous about what I was doing, maybe exhausted, and I came into the loft one day and I tacked up a canvas on the wall, I never paint on an easel, a very old loft full of dirty skylights and a lot of crap around, I thought, I'll just paint what I see, don't think.  So I painted the whole loft, like one of those Matisse's—easel, broken chairs, electrical wire hanging down, all the way right up to my hand below painting it. I worked steadily for eight hours without stopping.  I ran across the street, got my wife. "Look at that, I can paint.  It's as good as a Bonnard."  I was really upset.  This denied everything I was doing.  It's one of those funny moments you have.  I'm puzzled all the time by representation or not, the literal image and the nonobjective, there is no such thing as nonobjective art. Everything has an object, has a figure.  The question is, what kind?  Does it have illusions, in what way can you have figuration?

In this case I painted, quite literally, with fancy colors, dirty grays, nice pinks, ochres. Looked terrific.  I had a hard time sleeping that night.  I was very upset; where do I go; is this a new career, or what?  Am I changing?  Am I afraid to change?  All these psychological problems.

I came in the next morning and there was nothing there—literally nothing there. There was a representation of all this, but it seemed like a fake, faked up, because it didn't seem real. It didn't seem concrete.  It didn't seem to have any life of its own. All it did was represent something and depended on all this recognition, like you have to be briefed on it, like, oh yes, a chair, a torn cloth, oh, yeah, a broken mirror.  It was composed nicely; it flowed and moved through one part into the other, all around your eye moved nicely, absolutely satisfying as a painting.

Well then, naturally, I proceeded to destroy it.  And then I had to rediscover again and again that, I guess, I'm not interested in painting.  I'm not interested in making a picture.  Then what the hell am I interested in?  I must be interested in this process that I'm talking about.  Sometimes a picture comes off, and I scrape off a lot.  I don't keep the studio very tidy.  You have on the floor, like cow dung in the field, this big glob of paint on the floor, and something comes off on the picture, and I look down at this stuff on the floor, and it's just a lot of inert *matter*, inert paint.  Then what is it?  I look back at the canvas, and it's not inert, it's active, moving, and living.  And that seems to me like some kind of peculiar miracle that I need to have, again and again.  Why I need this kind of miracle, I don't know, but I need it.  My conviction is that this is the act of creation to me. That's how I have it.  So, I'm in a corner with painting, and I can't seem to move out.  I've done this, painting the studio, again and again.  A few objects, paint cans on a table, recently, and it won't stay there. It won't stick there.  Last year I got involved with a five and dime coffee cup, cheap coffee cups are kind of nice, that ear—looks so ordinary.  Maybe I'll put in

two to make it interesting. It won't stick; it won't hold on the plane. Then you start shoving this form around; it gets pushed; it gets distorted, maybe one side goes up; one ear goes way out. It feels good. I don't know why. If you push it, it feels good. I don't know what it is. It must have something to do with the kinesthesia.

I feel now that I'm painting; I'm not drawing anything or even representing nonobjective art. You know, you can represent abstract art, too, as well as heads, figures, nudes. A lot of abstract artists are just representational painters, you know that. And a lot of figurative painters are very abstract. I don't feel as if I'm doing that. I feel more as if I'm shaping something with my hands. I feel as if I've wanted always to get to that state. If a blind man in a dark room had some clay, what would he make? I end up with two or three forms on a canvas, but it gets very physical for me. I always thought I was a very spiritual man, not interested in paint, and now I discover myself to be very physical, and very involved with matter. I want to be involved with how heavy things are; a balloon, how light things are; things levitating; pushing forms, make me feel as if my hand is pushing in a head, bulges out here and pushes there. Like feelings you all have, you see someone's head, and you want to push it, squeeze it, see what happens . . . or gravity interests me. You might be able to write a whole book of philosophy about if you had a ball and the floor was just tilted a little bit, at what point would the ball start rolling. Sometimes a form on a canvas gets in some peculiar positions, it's about to

fall, but it isn't falling, because some little thing is holding it up, some peculiar balancing is going on. I'm very involved with all this foolishness. Of course, I believe it's very significant, and not foolish at all. It becomes in my mind as important and as crucial as painting the baptism of Christ. I don't know why. It's very important to me. Maybe I'm skeptical about it all too, because it's a terrible state for man to get down to, but then modern life is like that; when you walk down the street you have to keep your balance, how you walk. I can listen to a couple of guys, as I did the other day, having a heavy philosophical discussion about Sartre, and instead of listening to them, I was watching the way the guy was shifting, the way his pants sagged, the way he shifted his weight on his hips. It seemed to be very important.

**JA:** Do you think it's harder to make the jump while working with the objects?

**PG:** Frequently I see painters working what's called nonfiguratively, nonobjectively, whether it's colored stripes or brush strokes or bull's-eyes. I think it's too limited. But we're not talking about making pictures, we're talking about one's experience, one's enlargement of oneself. That's what's important, how can you even continue to evolve, that's the point. How to bite off a big enough hunk of something so you *can* evolve. You don't always have to move horizontally, I feel now I'm going much more vertically. At one point earlier I thought I could do everything, and I painted all kinds of things. I could move horizontally through the landscape, just

conquering everything. Now I feel like I'm in a deep mine shaft. It feels inexhaustible to me. When I see people making "abstract paintings," I think it's just a dialogue, and a dialogue isn't enough. That is, there's you, and this canvas, but I think there has to be a third thing that must reverberate and make trouble. You have to have trouble and contradictions. It has to become complex because life is complex, emotions are complex. Whether that third thing is a still life, an idea, or a concept. In each case, it has to be a trialogue, and has to, above all, involve you. Painting from something is no assurance of anything at all. Just painting some recognizable objects doesn't matter. The real thing that matters is how involved you are. I can certainly imagine there are painters who are involved in painting some objects, or with stories they want to tell, who are just as involved as I am in putting what where, which is *my* third thing. It's a simple act of deciding limitations rather than just beginning, which I feel a lot of abstract painting does. "Abstract," "representational," I don't think of painting in that way. It seems somewhat irrelevant, except as it might exist as a problem to an individual. Then it becomes interesting and exciting because then there is conflict, and conflict's exciting. A painting is a flat surface upon which unequal lights are placed, different colors are unequal lights whether it's soft edge or hard edge and so on.

You have a preconception, an expectation, and then you simply proceed to meet that expectation. You have a measure. You know when it's finished. You know when

to stop. The original revolutionary impulse about the New York School was that nothing could really be decided. Painting will have to be, no matter what form it takes in our time, in modern life, a continuing, plaguing, harassing argument about whether it should exist, whether you can create, and under what psychological and philosophical conditions can you create. That seems always to be current.

Painting is some paint on a flat surface, and I'm talented and can make all kinds of "doohickeys." You can make a pretty good living at it because the whole climate is prepared for it. Coming back to the original question, about why Abstract Expressionism had this demise, it is that there's no audience for it. I think it would be too demanding for the audience, because it would involve the same kind of feeling and thinking and questioning that the creator puts into it. In other words, it demands this kind of participation. Now, if you are going to tell me that a lot of these paintings are in museums and in collections and in books, that's true, but I believe it was seen as an interesting new style and not for what it was really about.

**JA:** Do you think you're related to older painters?

**PG:** Who?

**JA:** Chardin.

**PG:** Oh yeah. You know somebody where I'm teaching now [Brandeis University] said he was giving a course in modern art. I was lonely that night, and I was prepared for a discussion, and I said,

"Do you start with Cézanne or Delacroix?" "Oh no," he said, "I start with Noland and Morris Louis." So when you say "older" you might mean Rothko, or me, or deKooning, I don't know. Or Chardin . . . what gallery is he showing in? (Laughter from the room.)

**Audience:** I was wondering if you were similar to Olitski?

**PG:** I don't think so. I think he's just a gorgeous painter, absolutely wonderful. But no, not similar.

It would be very nice to make a great unity of art through the ages. To some extent, the same things exist in the same basic principles. I'm forced to recognize that there is such a thing as modern art, probably since Cézanne—Cézanne is the key figure here. If you're interested in it, or involved in it, you're forced to the conclusion that there is such a thing as modern art, which is this peculiar individual activity the single man does. It's self-commissioned. Nobody's commissioning you to feel a need to make a painting, to create in such a way that the painting becomes a living, autonomous organism that can exist by itself. I'm puzzled by this, but I know this need is there. And a Chardin, no matter how wonderful or delicious to look at—it proposes all kinds of complex thoughts and emotions, the way the fruit is balanced, where everything is, the skin of the fruit, the dew on a cherry, the fuzz on this peach—it is so controlled. It's not a Dutch still-life painting by a long shot, its rareness is a very special thing, but I don't think he went through this kind of hassle at all. I

think Delacroix did somewhat, it varies.

**Audience:** Would you say that the sense of a living organism is less great in a Chardin or Piero than it would be in the best of the New York School?

**PG:** I don't mean to be perverse, but I certainly would rather look at Piero's *Flagellation* painting in Urbino or his *Baptism* picture in the National Gallery than I would at any modern painting. It seems so complete, so total, so balanced/unbalanced. All I can tell you is that I've had a reproduction on my wall of these two paintings for about twenty-five years in the kitchen, where you really look at things. I not only never get tired of them, but I see new things all the time. I'm at a point now where I don't even see the architecture. Everything I thought about them, everything that's written about them, is a lot of baloney. There is no architecture there at all. I think they are on the verge of chaos. I now think they are the most chaotic, disorganized pictures, trembling. They're posed there for a split second before they are going to become something else. They are the most peculiar paintings ever painted and more unclear than most modern paintings. The trouble with modern painting is that it's too clear. Some of the Old Masters are so unclear that you can't even fathom what their intentions were. Piero is a great inspiration to me. I used to be very influenced by his painting superficially, but I didn't know what I was seeing. I see something else now, maybe I'm seeing it for the first time. As a matter of fact I wrote about it, it took me a year. Com-

ing into the kitchen looking at the *Baptism*, at the *Flagellation* of Piero. I'd worked all night, I'd have something to eat around three or four, I'd keep looking at the thing, and I'd start writing about it. I commissioned myself, not to write—I don't write—but to put down my thoughts. I worked on this for about a year and a half, it was about two years ago that I started this business, and I wrote a lot and got involved with how to write—writing's very difficult. I ended up with a couple of paragraphs and it was printed in one of the art magazines in an issue on Piero della Francesca.

The reason I bring this up, is that I said something in there that I feel strongly about. Unlike the other masters of the Renaissance, particularly of the fifteenth century, his work has a kind of innocence or freshness about it, as if he was a messenger from God, looking at the world for the first time. In his *Baptism*, it's as if he came down to earth and opened his eyes up for the first time. You see a tree, angels, some ground, a little bit of water, some reflections, sky, clouds, hills, limbs. It's as if he came down and opened his eyes up for the first time and started measuring and locating everything for the first time. It has that feeling. I want to do that. I want to paint a world as if it has never been seen before, for the first time, that's what I'd like to do. Maybe I have to go through this whole torturous business in order to do it; that's what I have to do to make painting worthwhile.

**Audience:** There's a painting at Brandeis that is titled *To Fellini*. When you finished it, you said that this painting is what Fellini is like. How did it become *To Fellini*?

**PG:** It's just a moniker, it has nothing to do with the painting. I was getting close to it, it was tightening, it was locking in, and on Forty-second Street where I used to live in New York there were two early Fellini movies. One was *The White Sheik* and the other was *I Vitelloni*, which I still think are his two great ones. I stopped painting at midnight. . . and you can go to the movie strip even at one o'clock and still see two features, you come out either refreshed, or sleepy, either way . . . so I was doing that week and when the painting came off I just said, "Homage to Fellini." In those two films, he's a great artist, particularly in *I Vitelloni*. It is about these young guys in a little town who don't know what to do with themselves. Everything is so sharply observed that all his ideas came out of the taste and flavor of life, his art was created out of this.

**Audience:** In relation to your discussion on Piero della Francesca, do you think that you're more, or can be more, conscious about this work than, perhaps, he was?

**PG:** Yeah. (Laughter from the room.) If you'll forgive my saying so, that's a pure Hollywood idea about artists [that they are not conscious]. The most expressionistic of painters, like Van Gogh, who's supposed to be this mad genius, he cut off his ear and he just was compulsive . . . did you ever read his letters to his brother, Theo? He was the most conscious of artists. He goes on for pages about Rembrandt, Giotto. Of course

painters know what they're doing, there's no such thing as an unintelligent painter. Whether you can write about it, or talk about it, is a question of individual predilection. Some could, some didn't, some couldn't. Delacroix wrote beautifully, Cézanne wrote beautiful letters . . . so did Pissarro. Corot didn't. Matisse hasn't written very much; Picasso has. But they certainly not only knew what they were doing, but knew what was involved with what they were doing.

**Audience:** Do you think that we read and think more than they did?

**PG:** Let's assume that we do read more into it today. It's possible that this is the evolution of our minds and imagination, that we become more complicated, more conscious of our processes, but try to avoid it. You could take various drugs, you could do all sorts of things and get out of it. But how are you going to avoid feeling certain contradictions and consciousness? A really wonderful part in the first book of the French Jesuit evolutionist, [Pierre Teilhard de] Chardin, *The Phenomenon of Man*, is when he talks about the great leap that must have occurred when man started to become fully conscious of his actions, and began to judge them, not just to kill and eat and sleep and reproduce, but to act and start thinking about all kinds of values. He suggests that it is the evolution of man, and that it's a continuing evolution. I found that book, that idea, very inspiring, not only to be so fully conscious of yourself, but even to be conscious that you're conscious. To act, to do something—and

watch yourself doing it—is a strange state of affairs, but it's an evolutionary process which is going to go on and on and on and leads, in art, to new subject matter, to new content. The question about whether Cézanne or Piero della Francesca really thought about all the things we think about is irrelevant. We see what we need to see.

**Audience:** Does the New York School, or art in general, need a more intelligent audience to keep in mind?

**PG:** Absolutely. I think the audience is dwindling in our time. Let's see if I understand your question right. I think art needs an audience, a serious high art needs a serious high audience. I don't know how it can exist otherwise, and in our time I'm not so hopeful about it. As I suggested a little earlier, I think we're going to have a leveling out, and a proliferation of mediocre artists and audience, where less is demanded, less is needed. Maybe that's natural, I don't know, maybe that's the way things go. I think that's happening now and will continue at probably even a greater rate of speed. The reverse might happen. There might be a countermovement, like an underground, like early Christian martyrs . . . you will pass a little poem, a private art, a little painting like you're supposed to do in the Iron Curtain . . . I don't know. That might be a good thing, like connoisseur's art, or an aristocratic art. Both could exist, side by side. There have been periods in the past where there's been art for the market place— thousands of prints and everything—and

BULLSHIT

yes

then there was the art of the palace. Chinese painting of the Sung period, if I am not mistaken, was somewhat similar. Big art of the marketplace—pictures of cockfights, wrestlers, genre painting—and, in the palace, statesmen, military men, and so on exchanged very special paintings that weren't bought or sold. They were like poems. These marvelous things we see now weren't public. It might happen again; I wish it would.

**Audience:** Could you say something about your latest paintings?

**PG:** I left the canvas showing all around. I seem to have done that over the past four or five years. It seemed to happen first just in a practical way. I don't stretch the canvas, I just put a big hunk of canvas on the wall and keep working, trying to locate these one or two images. When I stretch it, there's always an inch or two left. I remember when it first happened. I liked the feeling that there was bare canvas around because it seemed part of the total composition. The other reason I liked it was that it didn't pretend to be real, as if it said, painting is really an art of illusion. I want to show the canvas; that it's really just paint on canvas. The bare canvas seemed to be part of the complication that I liked, similar to making a drawing when you show some paper uncovered, or if you are working with clay, modeling as Rodin did, when the head is worked out and there's a bunch of clay. I wanted to show it's really just paint. Even though I'm trying to eliminate the paint, it's still paint. I enjoy that feeling.

**JA:** Do you have any thoughts about color? In the show, the recent works center mostly around grays and blacks, whereas your earlier works are painted with a broader range of color.

**PG:** Yes, I have had a lot of thoughts about it over the years. To begin with, I have never been really interested in color. I used reds a lot in the early fifties, to become acquainted with red. I didn't use many colors, but they may appear to be many colors. There are pinks and reds, a touch of green or blue, that's about all, and a touch of black. I feel that there has to be a moral value to color. Why should there be this color, or that color, or that color? It took me a few years to get the feeling of red and, in particular, cad red medium, which I happen to love. That just is like somebody saying, "I like pastrami." I can't tell you why. I like cad red medium. It has a certain resonance, a certain thing, particularly because you can go both ways with it—a little black goes well with it, a little pink goes well with it. I'm more of a tonal painter, maybe, I work with a few tones. I don't think I have ever been a colorist, working with color to create space. I've tried to locate forms more with tone. Color puzzles me. I become attached to a single color and work with it for years. I worked with blue for a few years and got involved with blue. And blue, I really don't understand at all. But red, this cad red medium seems to stay on the plane. You can't budge it, it's there. Blue is nowhere, it really bothers me unless I put black on it to hold it, as if I put my foot on it, to hold it there. Or green. I look at

Bonnard, and I think he's really a mar-
velous color painter, his whole tapestry of
color is magnificent, wonderful. His vision
is perfect. Lately, I have had a feeling that
I wasn't much involved with color, and
since the red seemed to go, I didn't seem
to need it or feel it anymore. I am not
even interested in red anymore. So what's
there to work with? Black? I don't even
think of it as black, it's just stuff you put
on. If you don't like it when it's over here,
well, you take it out with white, so it gets
gray. Then you put the mud over here, and
then you don't like it there, it goes out, so
you put it over there. The whole picture
ends up being this kind of thing. But I am
aware of light. I discovered that even
though you work with gray, white and
black, you can't avoid light. Fortunately,
it's marvelous to create light, and then I've
always admired, always puzzled over, some
of the masters like Goya, Zurbarán—
whose magnificent monks in the Prado
are painted just in gray and white—and
Hals, and the late Rembrandts, painted
with just a few tones. Gray and black seem
magnificent to me. I want to see how
much I can do with very simple things,
just two colors, white and black, and a
brush in my hand—nothing to paste on. I
want to see if there is anything left to
express with the most elementary means.
So far I have found it very challenging and
inexhaustible.

NOTES

1.    This transcript is from a tape recording
located in the Karl Fortess Collection, in the
Boston University Archives. An excerpt of this
interview was published as the "Boston
University Talk" in Guston's 1980 retrospective
exhibition catalogue organized by the
Museum of Modern Art in San Francisco. See:
Philip Guston, "Statements by the Artist," *Philip
Guston* (San Francisco: Museum of Modern
Art, 1980), 45–47.

CATALOGUE

*Yellow Light* (1975) gives visual form to Guston's experience in his studio. In this painting, Guston portrays himself as a pale profile menaced by a group of unearthly heads. These floating beings are his own creations, his ideas made manifest. Their vivid yet ominous presence reflects the artist's ambivalent relationship to his own work.

In speaking of his paintings, Guston often remarked on his feelings of pride and fear in viewing his finished work:

It doesn't occur to many viewers, that the artist often has difficulty accepting the painting himself. You can't assume that I gloried in it, or celebrated it. I didn't. I'm a night painter, so when I come into the studio the next morning the delirium is over. I know I won't remember detail, but I will remember the feeling of the whole thing. I come into the studio very fearfully, I creep in to see what happened the night before. And the feeling is one of, "My God, did *I do that?*" That is about the only measure I have. The kind of shaking, trembling of . . . "That's me? I did that?"[1]

Having left in the studio "a 'person,' or something that is a thing, an organic thing that can lead its own life, that doesn't need me anymore," Guston was forced to confront the consequences.[2] His paintings, as Robert Storr has noted, are simultaneously organic beings that demonstrate his creative power, and menacing realizations of his own corruption.[3] *Yellow Light* records this encounter between the artist and his creations.

Formally, the painting is divided horizontally in half with the lower section forming a "blank" space, thinly covered with broad strokes of pale color—bare canvas shows through in several places. Compositionally, this flat expanse mediates between the public arena of the viewer and the private world of the artist. Above its horizon, Guston's self-portrait rises.

Guston portrays himself staring at his own creations, and he is both awed and overwhelmed by their presence. The artist situates his head near the center, barricaded on the left by a brick wall and confronted on the right by four disembodied heads. Guston's profile directly confronts one, whose portrait is a stylized version of his own. Compared to Guston's vulnerability, this head is full of life and power. Its bold contour contrasts with the artist's timid pink outline; its black iris challenges Guston's vacant, blind eye. An ominous quality is apparent in the creature's commanding presence. The force of its stare makes an indentation in Guston's face. This physical reaction is accentuated by the bloodred shadow that spills over the lower half of the painting. Amazed and horrified by his own monstrosities, Guston infuses *Yellow Light* with a potent description of the private world of the artist.

Jean Graves

1. Philip Guston, "Philip Guston Talking," in *Philip Guston, Paintings 1969-1980*, ed. Nicholas Serota (London: The Whitechapel Art Gallery, 1982), 55.

2. Philip Guston, "Philip Guston's Object: A Dialogue with Harold Rosenberg," *Philip Guston: Recent Paintings and Drawings* (New York: Jewish Museum, 1966), n.p.

3. Robert Storr, *Philip Guston* (New York: Abbeville Press, 1986), 60.

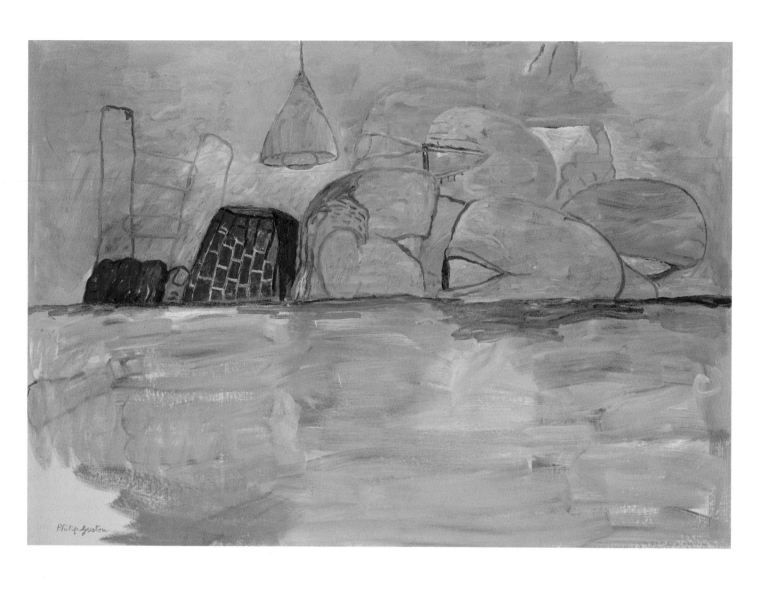

PLATE I

*Yellow Light*, 1975

Oil on canvas, 67½ x 96¾ in. (171.5 x 245.8 cm.)

Private Collection, Courtesy McKee Gallery, New York

43

In *Division* (1975), Guston brings together in one painting two distinct themes from his late oeuvre, that of the "paint table" and the "deluge." Painted intermittently throughout the mid 1970s, these two themes were generally treated by the artist as two separate series. In *Division*, however, Guston combines the paint table and the deluge imagery into a single work. The result is a densely constructed painting that abstractly and metaphorically interweaves layers of visual and thematic elements.

Compositionally, *Division* is separated into three horizontal zones. The upper zone is a painting within a painting containing deluge imagery. It depicts heads, shoes, and books floating among waves. The middle zone portrays a paint table on which there are brushes, globs of paint, and a can. The narrow, lower register denotes the space in front of the paint table. It includes a canvas leaning against and overlapping the edge of the paint table.

The distinct zones in *Division* suggest three different representational spaces or levels of reality. The paint table is the center zone that literally and metaphorically links the parts of *Division*. The paint table joins the upper and lower zones by connecting the artist's working world, represented by the palette, with the artist's fantasy, represented by the deluge. It is both the site and the process through which the viewer must pass in order to move from the tangible world of the studio to the painted world of the artist.

Guston's shifting, ambiguous representation of space allows *Division* to oscillate between the figurative and the abstract. Each horizontal zone reads as an illusionistic space in which "real" objects are accorded three-dimensional space, and simultaneously reads as a flat plane which denies three-dimensional reality. For example, the palette is both inflected into space and sitting vertically on the picture plane. The paint can is painted in perspective; however, the brushes are not at all foreshortened. Further, the artist's rendering of paint coincides with the reality of actual paint spread on the canvas. The exact substance is both itself and what it purports to imitate.

The deluge register similarly plays with two competing realities. In relation to the painting table zone, it displays a more consistently deep space where phantom objects emerge from its hidden depths. Distinct from the clearly defined and contained geometry of the paint table, the deluge zone is murky and unbounded. This suggests a distinction between the levels of reality represented in the two registers, with the deluge zone connoting the world of the unconscious. In a late interview, Guston refers to his creation of the deluge imagery: "I began working at my painting table and then the water above it gave me the idea of a flood with people drowning."[1] His reference shows a surprising ambiguity about what is "real." Guston does not indicate where this water is located. Is it outside his studio, on the canvas he is painting, or on a different canvas? Such formal ambiguity and representational play pervade *Division* and display the complexity of Guston's ruminations on abstraction and figuration.

Russell Roberts

1. Philip Guston, "Philip Guston Talking," in *Philip Guston Paintings 1969–1980*, ed. Nicholas Serota (London: The Whitechapel Art Gallery, 1982), 54.

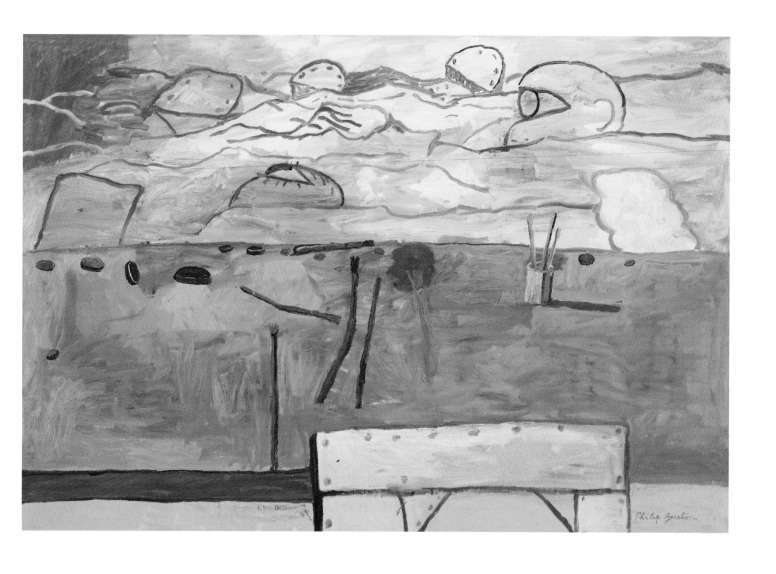

PLATE 2

*Division,* 1975

Oil on canvas, 60 x 89 in. (152.4 x 226 cm.)

The Estate of Philip Guston, Courtesy McKee Gallery, New York

45

In *Curtain* (1977), Guston infuses traditional still life elements with a modern instability, an animation that obscures the boundaries between abstraction and figuration. *Curtain* presents a series of domestic objects—book, coffee cup, and two cherries —against a backdrop of tasseled drapery. The curtain is theatrically pulled back from the table and enframes the objects. Blown up to monumental proportions and endowed with spatial and formal ambiguities, these everyday items are not represented in a conventional manner.

Guston alternates between a perspectival representation of the still life and a self-conscious assertion of the flat picture plane. All of the objects ostensibly occupy the same space. The cup and cherries sit on the back edge of the table and are depicted at eye level. The book, however, tilts up toward the viewer and is seen from above. This shifting of perspective challenges the conventional relationship between objects and space.[1] Within each element, the play with the concept of representation continues. The figures are both tangible, three-dimensional objects and painted, two-dimensional shapes. Guston boldly outlines the coffee cup and describes its rim with a flat, white band of color. This flattening of the form is countered by the addition of dash marks across the surface of the cup that signal its rounded shape. These marks, however, are so crudely done that Guston purposefully mocks the formal techniques used to describe three-dimensional objects. The artist both participates in traditional still life genre and subverts it.

Guston also undermines conventional form by transforming the still life elements. His interest in metamorphosis is apparent in the shifting of the objects. The handle of the coffee cup becomes an ear; the dew on the cherries transpose into the markings on a clock; the weight of the drapery disappears into a thin wire cord. *Curtain* is not an exercise in mimetic representation, but an opportunity to re-create ordinary objects into extraordinary images.

Blake Morandi

1.    Ablow states that the placement of objects was of great interest to the artist. At this time, Guston studied the work of Chardin, enthralled over the Frenchman's small still life compositions. Joseph Ablow, interview with Mary Drach McInnes, April 1994, Boston.

PLATE 3

*Curtain,* 1977

Oil on canvas, 68 x 104 in. (172.7 x 264.2 cm.)

The Estate of Philip Guston, Courtesy McKee Gallery, New York

47

*Sleeping* (1977), a striking self-portrait of the aging artist, is one of the final bed portraits painted by Guston between 1971 and 1977. The artist represents himself pulled up in a fetal position and burrowed beneath a brilliant red blanket. At the top of the canvas, one sees his wild mop of gray hair. The blanket clings to the forms of his body, covering yet simultaneously emphasizing his enormous belly and spindly legs. Though the blanket is protectively pulled up over Guston's torso and face, his bare ankles and the soles of his shoes protrude from the bottom.[1] The spindly legs underscore the vulnerability of the sleeping figure.

This isolated self-image of Guston differs markedly from the bed portraits of the early seventies. In *Sleeping*, the artist's body fills most of the canvas. Outlined by the clinging red blanket and silhouetted against the empty black background, the tipped-up figure offers a complete view of his anatomical mass. By contrast, Guston's body in *Painting, Smoking, Eating* (1973) is severely flattened by the pale pink shroud of bed covers. In his early bed portraits, Guston's body becomes a table. Here, it supports a large plate of french fries. The negation of the torso directs attention to the head and surrounding objects. Guston may be in bed, but he is not sleeping. Alert and wide-eyed, he calmly puffs on a cigarette. His furrowed brow shows that he is thinking. Indeed, the pile of shoes, brushes, and paint cans that surround the figure are imaginary, visual manifestations of his thought process.[2] The artist's consciousness, his depiction of activity, and the realization of his thoughts stand in stark contrast to the portrait in *Sleeping*.

Guston's dark and isolated self-portrait of 1977 reflects the artist's recent confrontation with death. It was painted shortly after his wife Musa's stroke and a year after his own hospitalization. *Sleeping* depicts a new, and increasingly grim image of the artist. The palette mirrors this transformation. The largely pink and white tones of the early seventies give way to a dramatic composition dominated by pure cadmium red and black. These elemental and highly contrasting colors wrap and isolate the figure. The void around the body emphasizes a new impenetrability of the formerly image-laden background. Finally, Guston no longer portrays himself engaged in activity, as in *Smoking, Painting, Eating*. His body, which was in decline after decades of hard drinking and heavy smoking, is now the focal point of the composition. Guston's covering, his fetal position, and closed eye shows a man concealed, vulnerable, and unconscious. In this late self-portrait, Guston depicts himself as a solitary and tired man.

Blake Morandi

1. Rosenthal has suggested that the oft-repeated imagery of the shoe soles invites "an obvious pun: the sole of a shoe recall[s] the soul who inhabits this article of clothing." The shoe nails then take on further significance—piercing and perforating the "sole-soul." See: Mark Rosenthal, "Guston's Metamorphosis: A Matter of Conscience," *Philip Guston, Retrospectiva de Pintura* (Madrid: Centro de Arte Reina Sofía, 1989), 162.

2. Philip Guston, "Philip Guston Talking," in *Philip Guston Paintings 1969–1980*, ed. Nicholas Serota (London: The Whitechapel Art Gallery, 1982), 61.

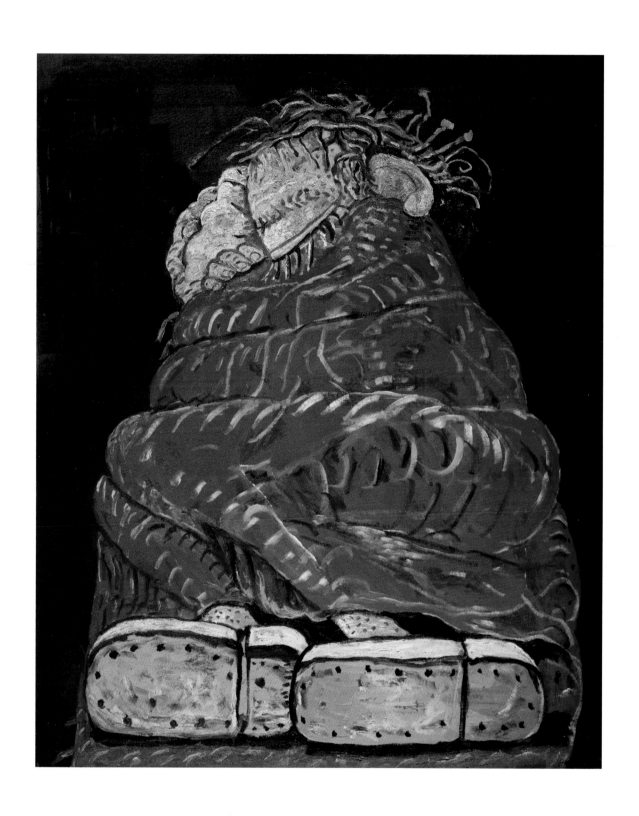

PLATE 4
*Sleeping,* 1977
Oil on canvas, 84 x 69 in. (213.4 x 175.3 cm.)
Private Collection, Courtesy McKee Gallery, New York

49

"Les Chevaux du Temps" by Jules Supervielle

*Quand les chevaux du Temps s'arrêtent à ma porte*

*J'hésite un peu toujours à les regarder boire*

*Puisque c'est de mon sang qu'ils étanchent leur soif.*

*Ils tournent vers ma face un oeil reconnaissant*

*Pendant que leurs longs traits m'emplissent de faiblesse*

*Et me laissent si las, si seul et décevant*

*Qu'une nuit passagère envahit mes paupières*

*Et qu'il me faut soudain refaire en moi des forces*

*Pour qu'un jour où viendrait l'attelage assoiffé*

*Je puisse encore vivre et les désaltérer.*

When the horses of Time are halted at my door

I am always a little afraid to watch them drink

Since it is with my blood they quench their thirst.

They turn upon me a look of recognition

And I am overwhelmed with weakness from their lengthy draughts.

They leave me so weary, so elusive and alone

That an interval of dusk descends upon my eyelids

And I must suddenly build up my strength again

So that each day the thirsty creatures come

I can be still alive, and slake their thirst.

From Jules Supervielle, *Selected Writings*. Trans. James
Kirkup (New York: New Directions Publishing
Corp., 1967), 42–43. Reprinted by permission of
New Directions Publishing Corp.

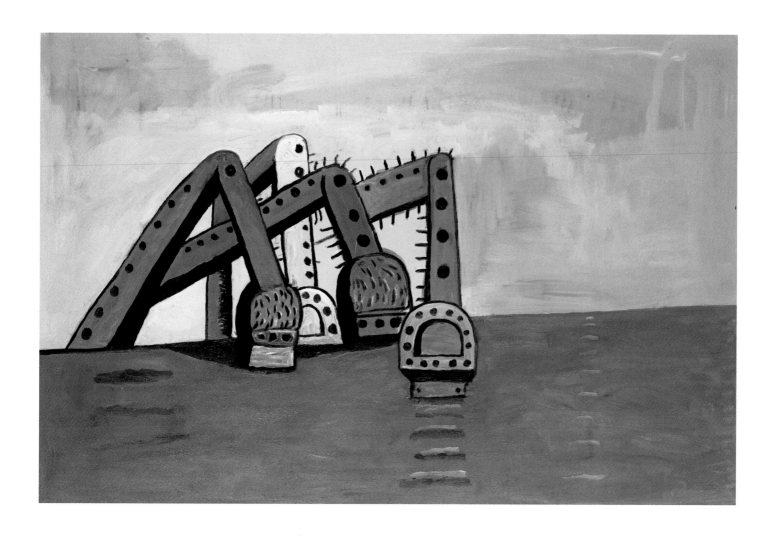

PLATE 5

*To J. S.*, 1977

Oil on canvas, 68 x 104 in. (173 x 264.2 cm.)

The Estate of Philip Guston, Courtesy McKee Gallery, New York

51

I am on my way to Leszniów, where the Divisional Staff is quartered. My companion, as before, is Prishchepa, a young Cossack from the Kuban—a tireless ruffian who has been turned out of the Communist Party, a future rag-and-bone man, a carefree syphilitic, and a happy-go-lucky fraud. He wears a crimson Circassian coat of fine cloth, and a downy Caucasian hood is thrown back over his shoulders. On our journeys he has told me his story.

A year ago Prishchepa ran away from the Whites. In revenge, these took his parents as hostages and put them to death. Their property was seized by the neighbors. When the Whites were driven out of the Kuban, Prishchepa returned to his native settlement.

It was early morning, daybreak. The peasants' slumber sighed in the acrid stuffiness. Prishchepa hired an official cart and went about the settlement collecting his phonographs, wooden kvass-jugs, and the towels his mother had embroidered. He went out into the street in a black felt cloak, a curved dagger at his belt. The cart plodded along behind. Prishchepa went from neighbor to neighbor, leaving behind him the trail of his blood-stained footprints. In the huts where he found gear that had belonged to his mother, a pipe that had been his father's, he left old women stabbed through and through, dogs hung above the wells, icons defiled with excrement. The inhabitants of the settlement watched his progress sullenly,

smoking their pipes. The young Cossacks were scattered over the steppe, keeping the score. And the score mounted up and up—and still the settlement remained silent.

When he had made an end, Prishchepa went back to his despoiled home and arranged the furniture he had taken back in the places he remembered from childhood. Then he sent for vodka, and shutting himself up in the hut, he drank for two whole days and nights, singing, weeping, and hewing the furniture with his Circassian saber.

On the third night the settlement saw the smoke rise from Prishchepa's hut. Torn, scorched, staggering, the Cossack led the cow out of the shed, put his revolver in its mouth and fired. The earth smoked beneath him. A blue ring of flame flew out of the chimney and melted away, while in the stall the young bull that had been left behind bellowed piteously. The fire shone as bright as Sunday. Then Prishchepa untied his horse, leaped into the saddle, threw a lock of his hair into the flames, and vanished.

From Isaac Babel, *The Collected Stories*. Ed. and trans. Walter Morison. Intro. Lionel Trilling (New York: S. G. Phillips, 1994), 108-109. Reprinted by permission of S. G. Phillips.

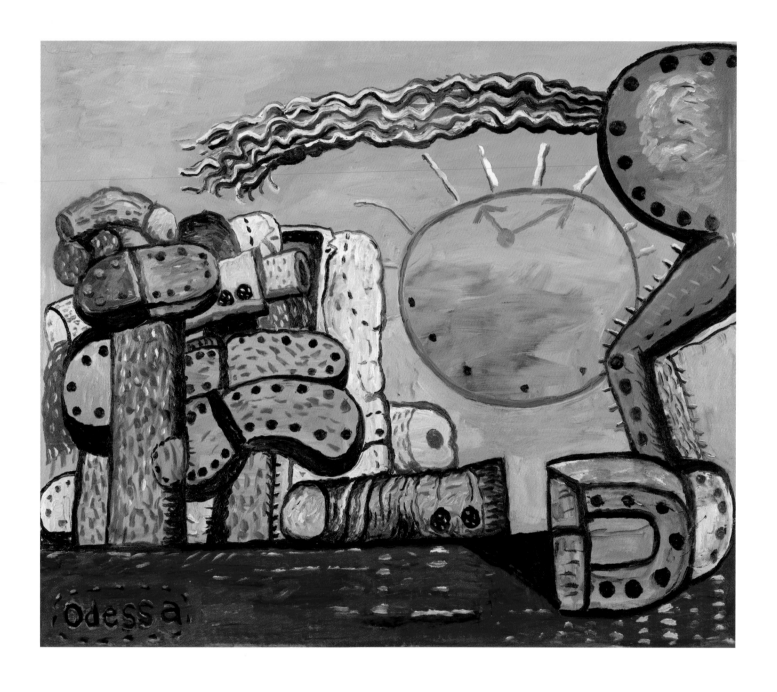

PLATE 6

*To I. B.*, 1977

Oil on canvas, 67 ¼ x 80 in. (170.8 x 203.2 cm.)

The Estate of Philip Guston, Courtesy McKee Gallery, New York

53

*Aegean* (1978) is a contest between the civilized and the barbaric, between the present and the past. The title suggests the Homeric roots of Western civilization, a culture in which aggression and combat were celebrated as proof of manhood. The imagery, however, offers us a more timeless struggle and an ironic text on man's violent nature.

Five disembodied forearms wielding stylized shields oppose each other in midair. Rushing inward from the margins, these fists meet and lock themselves in perpetual conflict. Yet this is not one war between two opposing sides but five individual struggles. All the limbs are different colors, sizes, and shapes which indicate discrete identities. While each is separate from and opposed to the others, they seem to reproduce themselves. Shield-wielding fists spring fully formed from other shields. The combatants seem united in their contest. Moreover, the drama moves back and forth in a horizontal rhythm with no central focus or single meeting place, with no apparent beginning or end. Such continuous movement reinforces the ongoing nature of this conflict. A wrist-watch worn by one warrior indicates the timelessness. Literally, the watch is timeless; its face has no hands to tell time. Figuratively, the timepiece encompasses both past and present; its modernity counters the antiquity of Homeric title and beastlike arms.

This timeless commentary is endowed with a grave irony. None of the combatants uses a weapon, and their actions seem to be defensive. One wonders, do these warriors fight to maintain their individuality or simply to resist the otherness of their opponents? Brandishing brightly colored shields, they protect themselves only from those who are similarly shaped and similarly motivated. Given their common humanity, their continued engagement is a dark, ironic reading on Man's violent nature.

Jean Graves

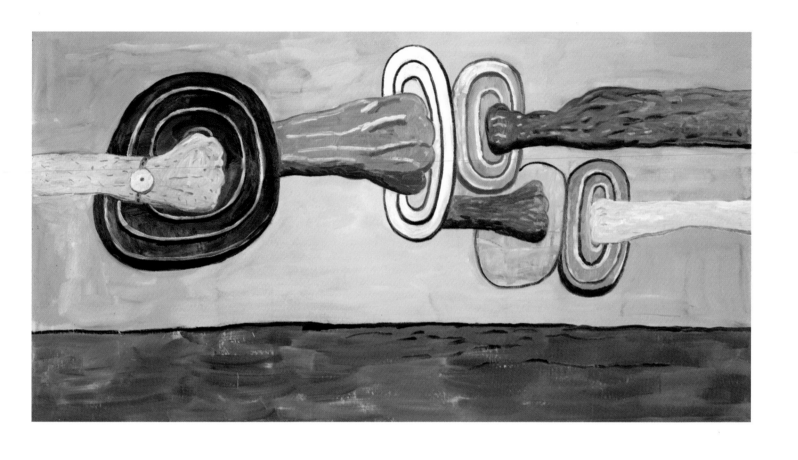

PLATE 7

*Aegean*, 1978

Oil on canvas, 68 x 126 in. (172.7 x 320 cm.)

The Estate of Philip Guston, Courtesy McKee Gallery, New York

*Feet on Rug* (1978) is an "impossible" image. It depicts two feet, severed above the ankles and placed on a fringed, red rug. The feet, set against a red ground and blue sky, are monumental in stature. Unlike other Guston canvases of this period, the limbs are isolated, not part of a general piling-up of disembodied body parts. They alone are the focal point and are endowed with their own life. Painted in flesh tones, the two right feet are represented with the improbable ability to walk off the rug. Both feet point in the same direction, one poised in front of the other as if they had just taken a small step. They seem to tremble on the surface; dark shadows beneath the soles indicate a movement off the floor. Quivering lines of red and white paint across the tops of the feet add to their agitated quality. The tense energy of the feet is echoed in the rug's irregular shape. The fringe curves and suggests movement, as if the rug were able to crawl across the floor like an insect. The ostensible animation of lifeless objects—the severed feet and the fringed rug—is a paradox which is consistent with Guston's play with the real and surreal in his late figurative work.

*Feet on Rug* is intentionally anti-aesthetic and impure. The alternation between still life and animation may also be read as the painter's commentary on the relationship between painting and life. Guston repeatedly described his shift to figurative imagery in the late sixties as a rejection of the Abstract Expressionist myth "that painting is autonomous, pure and for itself."[1] In *Feet on Rug*, the forms are not only representational but deliberately banal, heavy, and clumsy. The simplicity of the figurative elements—"feet" and "rug"—have a tangible connection with physical reality. Yet, these familiar forms become surreal images. Through his imagination and will, Guston transforms this lifeless image into an animated entity. The limbs, while fragments, suggest that the "impossible" is made "possible" in painting. Though disembodied, the feet are made whole by art.

Blake Morandi

1.  Musa Mayer, *Night Studio: A Memoir of Philip Guston by His Daughter* (New York: Penguin Books, 1988), 141.

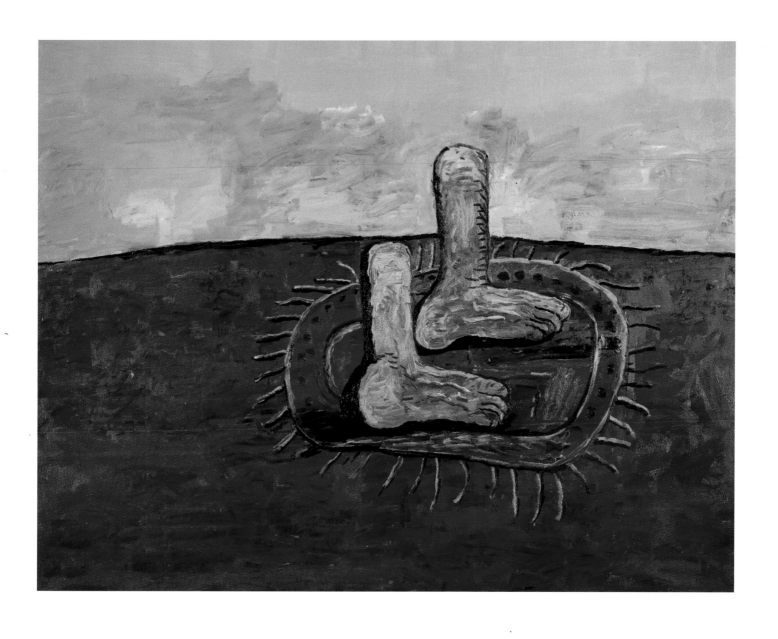

PLATE 8

*Feet on Rug*, 1978

Oil on canvas, 80 x 104 in. (203.2 x 264.2 cm.)

The Estate of Philip Guston, Courtesy McKee Gallery, New York

In this untitled painting of 1978, Guston presents a close-up cartoon image of a painter's hand descending from the sky and landing on a landscape of paint. Playing with fine-art techniques and traditional iconographic motifs, Guston constructs a painting that reads as a self-portrait, a landscape, and a still life. This shifting among genres asserts the painter's creative ability and mocks the modernist obsession with the purity of art.

On one level, this painting is a self-portrait. Instead of featuring his face, Guston depicts only his painting hand. He identifies himself through one of his personal habits—the ever-present cigarette—and his professional tools—brush and paint. The self-portrait participates in both the "high" art conventions of the Renaissance and the "low" art conventions of the comic strip. A large hand dramatically descends from the upper corner, purposefully recalling the traditional image of the hand of God descending from the sky. Guston, who studied Renaissance painting, was familiar with this iconography. Read symbolically, the artist is equated with God and is endowed with supernatural powers. The hand of the painter is a godlike object which reaches down to his palette to create new form. This referencing of religious iconography, however, is immediately subverted by the manner in which the hand is described. It is boldly and simply drawn. Lacking detail, modeling, and naturalistic coloring, the hand assumes a cartoon identity. The figure, borrowed from popular culture, attacks the "high" culture and challenges the "purity" of art.

Guston's self-portrait may also be read as still life or landscape. The disembodied hand becomes part of the overall assemblage of the artist's palette. Six brightly colored mountains of paint sit on the surface. This close-up vision of the painting table dramatically shifts scale to become a landscape. Guston, who once dismissed paint as "only colored dirt," creates a large desert of pigment on this canvas.[1] The waft of smoke becomes a cloud; the lumps of red and green paint transpose into large mountains; the squeezed black form transforms into a cartoon car. Two radically different scales are simultaneously suggested. Is this a magnified image of Guston's hand and palette, or the hand of God descending into a fantastic desert of colored mountains? Guston puts scale, form, and genre into continual play. The power of the artist is, ultimately, the subject of this painting.

Anja Rauh

1.    Morton Feldman in Guston file, Library of the Museum of Modern Art, New York, quoted in Robert Storr, *Philip Guston* (New York: Abbeville Press, 1986), 60.

PLATE 9
Untitled, 1978
Oil on canvas, 42 x 48 in. (106.7 x 121.9 cm.)
Private Collection, Courtesy McKee Gallery, New York

59

In the year before he died, Philip Guston painted the elegiac *Flame* (1979). Death must have been on the painter's mind. His health declined throughout the late seventies; he was hospitalized for exhaustion in 1976 and had a near-fatal heart attack in 1979. Further, his wife Musa suffered a stroke during this period. In *Flame*, Guston transforms his personal battles into an iconic image of death and eternal life.

Fire erupts from a ghostly brazier in Guston's dark canvas. Set on a red pedestal, the brazier is described with childlike simplicity. Guston animates the container, its bulbous pot held up by three quivering legs. A spidery, Medusa-like spray of flames erupts from the urn. Red and mauve brush strokes form a rich tapestry of pigment. In contrast to the tentative description of the brazier, the flames are endowed with great physicality. The vitality of this light is accentuated by the darkness from which it emerges. The brazier and pedestal are set against—indeed, painted over—a dense background of black. This void shimmers with oily paint. Black and reddish black pigments are applied in a grid of thick horizontal and vertical strokes. Here, the painter seems to be conjuring up his abstract fields of the fifties and sixties.

Unlike his clear, cartoon narratives, *Flame's* figurative element merges with the background. There is a formal resolution between the lit brazier and the surrounding void. Guston draws the figure over the black field, which allows the background to come through and become part of the image. The transparency of the urn aids in pairing the figure and ground. The tricol-or palette of black, cadmium red, and white used throughout the canvas also adds to a formal harmony.

This late painting is not only formally resolved, but it seems to thematically conclude the artist's personal battle with death. Guston leaves behind his bean-shaped heads and comic-book props for an iconic image of death and everlasting life. Darkness and light, despair and hope, are both represented in *Flame*. As a funeral pyre or an Olympic flame, Guston's image attains a solemn grandeur.

Mary Drach McInnes

PLATE 10

*Flame*, 1979

Oil on canvas, 69 x 74 in. (175.3 x 188 cm.)

Private Collection, Courtesy McKee Gallery, New York

Dimensions are given in inches, height preceding width.
Metric measurements are in parentheses.

*Yellow Light,* 1975
Oil on canvas, 67 ½ x 96 ¾ in.
(171.5 x 245.8 cm.)
Private Collection
Courtesy McKee Gallery, New York

*Division,* 1975
Oil on canvas, 60 x 89 in.
(152.4 x 226 cm.)
The Estate of Philip Guston
Courtesy McKee Gallery, New York

*Curtain,* 1977
Oil on canvas, 68 x 104 in.
(172.7 x 264.2 cm.)
The Estate of Philip Guston
Courtesy McKee Gallery, New York

*Sleeping,* 1977
Oil on canvas, 84 x 69 in.
(213.4 x 175.3 cm.)
Private Collection
Courtesy McKee Gallery, New York

*To J. S.,* 1977
Oil on canvas, 68 x 104 in.
(173 x 264.2 cm.)
The Estate of Philip Guston
Courtesy McKee Gallery, New York

*To I. B.,* 1977
Oil on canvas, 67 ¼ x 80 in.
(170.8 x 203.2 cm.)
The Estate of Philip Guston
Courtesy McKee Gallery, New York

*Aegean,* 1978
Oil on canvas, 68 x 126 in.
(172.7 x 320 cm.)
The Estate of Philip Guston
Courtesy McKee Gallery, New York

*Feet on Rug,* 1978
Oil on canvas, 80 x 104 in.
(203.2 x 264.2 cm.)
The Estate of Philip Guston
Courtesy McKee Gallery, New York

Untitled, 1978
Oil on canvas, 42 x 48 in.
(106.7 x 121.9 cm.)
Private Collection
Courtesy McKee Gallery, New York

*Flame,* 1979
Oil on canvas, 69 x 74 in.
(175.3 x 188 cm.)
Private Collection
Courtesy McKee Gallery, New York